Cristina Acidini Luchinat

BENOZZO GOZZOLI

SCALA/RIVERSIDE

The illustrations for this volume come from the SCALA ARCHIVE, which specializes in large-format colour transparencies of visual arts from all over the world. Over 50,000 different subjects are accessible to users by means of computerized systems which facilitate the rapid completion of even the most complex iconographical research.

© Copyright 1994 by SCALA, Istituto Fotografico Editoriale S.p.A., Antella (Florence)
Translation: Christopher Evans
Layout: Ilaria Casalino
Photographs: SCALA (M. Falsini, M. Sarri) except for: no. 8 (National Gallery, London); no. 15 (Vasari, Rome); no. 30 (Kunsthistorisches Museum, Vienna); no. 52 (Museum of Art, The John G. Johnson Collection, Philadelphia); nos. 53, 109 (National Gallery of Art, Washington); no. 54 (The Royal Collection Her Majesty Queen Elizabeth II, London, Hampton Court); no. 55 (Institute of Arts, Detroit); no. 78 (Bergamo, Accademia Carrara); no. 87 (Réunion des Musées Nationaux, Paris); no. 88 (National Gallery of Art, Ottawa); no. 89 (Metropolitan Museum of Art, New York; no. 91 (Cassa di Risparmio di Pisa S.p.A.)
Photocomposition: "m & m" Fotocomposizione, Florence
Colour separations: Mani Fotolito, Florence
Produced by SCALA
Printed in Italy by: Amilcare Pizzi S.p.A. - arti grafiche Cinisello Balsamo (Milan), 1994

"He who walks with difficulties along the road of virtue, even if it be (as the saying goes) both rocky and full of thorns, at the end of the climb finds himself at last in a broad plain, with all the happiness he yearned for. And looking down, seeing the cruel path he has trodden amidst perils, thanks God that he has led him to salvation, and with great contentment blesses those labors that had earlier caused him so much pain. And so making up for the sufferings of the past with the delight of the present, without toil though he strives to make those who watch him understand how the heat, cold, sweat, hunger, thirst, and hardship he suffered to acquire virtue, may free others from poverty and lead them to that safe and tranquil state, in which to his great content Benozzo took his repose".

With this lengthy introduction Giorgio Vasari commenced the biography of Benozzo Gozzoli in his *Lives of the Artists* in the Torrentini edition of 1550, reproduced without alterations in the Giunti edition of 1568. The elaborate rhetoric of this opening, in which Vasari makes use of the ancient and authoritative literary motif of the attainment of virtue through the ascent of an impassable and precipitous mountain, raises a number of questions owing to its lack of proportion and even relevance to the rest of the biography. This, in contrast, outlines an intense artistic career, studded with gratifications (although short on outstanding successes), but on the whole lacking in dramatic and surprising events. The career of a decent person and "true Christian", as Vasari himself describes Benozzo, that came to an end at a respectable age within a sound, family-based professional structure: his studio, which provided work for his sons Francesco and Alesso as well. So where were the difficulties and perils, the hazards and hardships which, according to Vasari's metaphor, Benozzo had to overcome before reaching a serene old age? In that great, never-ending labor that prevented him from enjoying any other diversion ("and he showed himself to be not much interested in other pleasures"), seems to be the biographer's answer, just a few lines later. But it is difficult to take him completely at his word, if we bear in mind the industriousness of Vasari himself, throughout his life and right up to his death. The true answer lies buried in the text of the narrative, as if censored by the writer's unconscious; and it consists, I believe, in a deprecatory or even subtly negative evaluation of the wandering from place to place among the "minor" centers of Tuscany and Umbria, with rare visits to Rome and Florence, which was the chief characteristic of Benozzo's artistic life. Vasari, it is known, associated the concept of the geographical

1. Saint Augustine leaving Rome detail of the presumed self-portrait San Gimignano, Sant'Agostino

and political "periphery" with that of cultural "backwardness". And the story of a painter who, despite having had the good fortune to be born in Florence, had then chosen to frequent the backwaters of provincial towns and villages, far away from the great commissions of the central authorities, could only appear, to a man who was an artist at the autocratic Medicean court of the sixteenth century, to be an uninterrupted series of tribulations. This secret thought would eventually be voiced by Roberto Longhi, always a shrewd interpreter of Vasari, who described Benozzo as "conditioned by living in the provinces" (Longhi 1960).

This scant esteem for Benozzo's art, inaugurated by Vasari with his unexpressed reservations and even more with his open criticisms (of the type: "even though he was not very good in comparison with many who surpassed him in drawing"; and a little further on: "among so many works there were also some good ones"), has lasted through the centuries right down to our own time, generating the conviction that he was a pleasant painter but confined within the limits of an old-fashioned emphasis on decoration in the Gothic manner, an "illustrator" rather than a genuine artist. A more recent historical viewpoint, distancing itself from the distinctions of remote idealistic origin between art and non-art that have conditioned much of twentieth-century art criticism in Italy, has made it possible to restore Benozzo (as the numerous studies by Anna Padoa Rizzo demonstrate) to his rightful place in the lively production of art and applied art that formed the basis for the flowering of the great masters of the Florentine Renaissance, as a worthy and versatile artist and craftsman, industrious and at the same time much appreciated by a number of illustrious patrons, including the Medici.

Benozzo was born in the fall-winter of 1421 to Lese di Sandro di Lese, from the citified branch of a family of farmers originally from Sant'Ilario a Colombaia, in the region of Badia a Settimo, part of the level district to the west of Florence. His mother was Monna Mea, eighteen at the time of his birth, and he had two brothers, Roberto, a year older, and Domenico, three years his junior. The name "Gozzoli" which, though absent from the 1550 edition of Vasari's *Lives*, appeared in that of 1568, comes from the name "Ghozzolo" common in the other branch of the family, the one that had remained in the country, a fact that Vasari had evidently come to know during the eighteen years that elapsed between the two editions.

The first evidence for his activity as an artist and craftsman, already a master of the trade even though there is no record of his having served an apprenticeship in any Florentine studio, dates from 1439, the year in which, according to the documents discovered by Padoa Rizzo (1991-2), he delivered to the Compagnia di Sant'Agnese al Carmine a painting of the *Ascension* ("Christ when he goes to heaven") on a funeral pall. In 1441 he painted a "compass" for Giovanni del Pugliese, which the latter donated to the same confraternity. In the family's declaration to the Cadastre in 1442 Lese stated that Benozzo, aged twenty, was "learning to paint"; but the modesty of this phrase (certainly prompted by the common desire to emphasize the family's liabilities and play down its earnings) obscured the real nature of an apprenticeship, or rather a collaboration, at a very high level with Giovanni da Fiesole, known as Fra Angelico, on the pictorial decoration of the Dominican convent of San Marco.

The complete integration of the youthful Benozzo's artistic style with that of Fra Angelico, a well-established master of over forty, has meant that it is only in recent times, thanks to the studies of Bonsanti (1990) and Padoa Rizzo, that it has been possible to identify with a fair degree of accuracy a variety of interventions by his hand. These span a period from 1438 to 1444-5, during which the extensive decoration of the convent's rooms and cells was carried out.

Fra Angelico was, for his young collaborator, the go-between with the generation of artists that, born toward the end of the fourteenth century, had been responsible for the sudden surge of innovation in the early decades of the fifteenth century, taking architecture, sculpture, and painting to new heights. This is why, in the view of historians of all ages, the early Florentine quattrocento marked the beginning of a new and splendid era in artistic culture, the Renaissance. From the firmly modeled masses of Fra Angelico, over which the light plays in a crystalline manner, producing pure and absolute colors, Benozzo was able to learn what he needed of the vigorous plasticism and coloring of Masaccio; while from the friar's more sophisticated and meticulous counterpoints of gold and ever-changing tints he picked up, without contrast, the exquisitely ornamental tendency of the International Gothic and the illuminative style of Lorenzo Monaco and Gentile da Fabriano. Benozzo made all this his own, combining it with his own more analytical interest in variety and wealth of detail. Gozzoli's participation in the mural decoration of San Marco has been recognized (thanks in part to the improvement in their legibility resulting from the restoration carried out by Dino Dini over the period 1975-83) both in decorative sections and in those of a more figurative nature. The ornamental fascia on the underside of the arch of the large lunette depicting the *Crucifixion* in the Chapter House has been ascribed to him (Padoa Rizzo 1992), but even greater artistic independence can be seen in the wall paintings of the cells assigned to him. In the beginning these interventions were limited to isolated figures (cell 5, angels in flight; cell 7, the Virgin Mary in the *Meditation on Christ Mocked*; cell 8, the three Marys in the *Marys at the Tomb*). Then he was given greater responsibility for composition and execution in various cells in the east corridor and the Novitiate. His decisive contribution to the *Prayer in the Garden* in cell 34 has been acknowledged, while the question of whether he should be considered the author of the intense *Crucifixions* on the side of the library (cells 41-4), whose high quality has been pointed out by Bonsanti, remains open. Finally there is general agreement that Benozzo was almost exclusively responsible

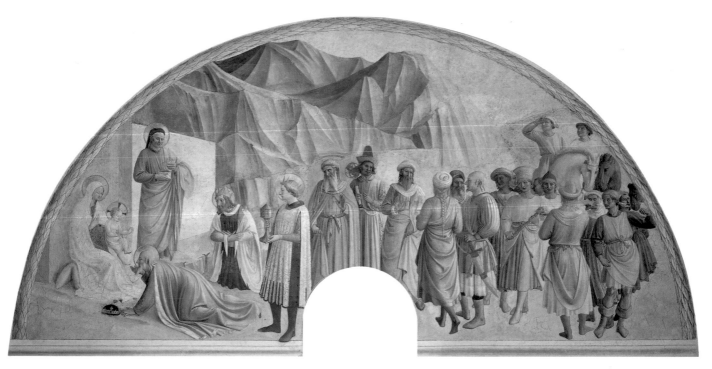

2. Fra Angelico and Benozzo Gozzoli
Adoration of the Magi
Florence, San Marco (cell 39)

3. Fra Angelico and Benozzo Gozzoli
Meditation on Christ Mocked, detail
Florence, San Marco (cell 7)

4. Fra Angelico and Benozzo Gozzoli
Marys at the Tomb, detail
Florence, San Marco (cell 8)

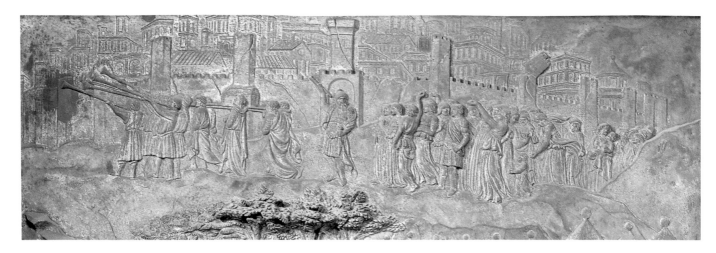

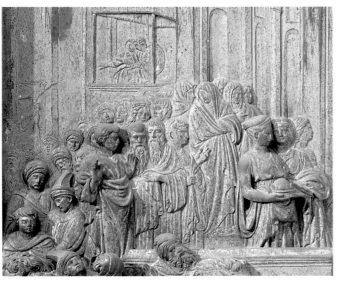

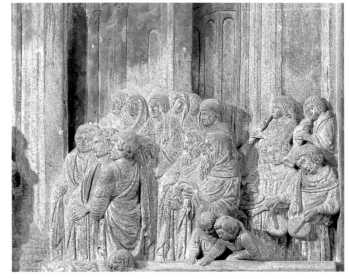

for the *Crucifixion with Saints Cosmas, Damian, John, and Peter* (vestibule, 38) and the *Adoration of the Magi* (cell 39), rooms which were both reserved for Cosimo de' Medici. In the procession of the *Adoration* Bonsanti has rightly indicated the work of another collaborator, "assistant no. 2" (perhaps the friar's nephew Giovanni d'Antonio della Cecca di Mugello), responsible for the more clumsy figures with their more rigid chiaroscuro. Gozzoli's work on the San Marco frescoes, in which he was an interpreter of Fra Angelico's ideas, with their already marked tendencies toward a softening of the range of colors, an attenuation of masses in favor of linear outlines, and more cheerful and lengthy descriptions of landscape in the settings, was certainly excellent. Yet this does not authorize us to regard his future career as "a slow, progressive decline from his youthful achievements" (Bonsanti 1990, p. 167).

The first signs of Benozzo's independent artistic activity appear to be paintings that critics have dated to the years of the decoration of San Marco and shortly afterward, up to 1446-7. They are works of small size and careful execution, that hint at Gozzoli's early vocation for the precious and calligraphic style of the illuminator. And it is in fact from this period that dates the manuscript of the *Profezie di Gioacchino da Fiore*, MS Harley 1340 of the British Library in London, depict-

5. Lorenzo Ghiberti and Benozzo Gozzoli Capture of Jericho, detail Florence, Museo dell'Opera del Duomo

6, 7. Lorenzo Ghiberti and Benozzo Gozzoli Meeting of the Queen of Sheba with Solomon, detail Florence, Museo dell'Opera del Duomo

ing the Popes (the last of whom is Eugenius IV, who died in 1447), recently assigned with conviction to Gozzoli (Bartalini 1990, pp. 114-16; Padoa Rizzo 1992, p. 23). This isolated venture into the art of illumination, rarely practiced as far as we know by Benozzo, is a sign of the open-minded and experimental attitude that drove him in those years, in his search for a clear vocation and a secure role, to acquire a diverse range of technical skills, to an even greater extent than was required by the integration of the arts in the typical Florentine studio. It was this curious and can-do approach that led him, I believe, to join for a couple of years the numerous group of artists who, under the guidance of Lorenzo Ghiberti, were working on the completion of the Door of Paradise and on "cleaning up" the bronze panels after casting. According to the contract of January 24, 1445 (1444 Florentine style),

Benozzo worked on the door for three years from March 1 of that year (the text is given in Krautheimer 1982); but in March 1447, that is a year before the end of this period, Gozzoli had already left for Rome to undertake an important commission at the papal court. The hypothesis that Benozzo may have played an active part in the execution of some panels, by modeling parts of the reliefs (Ciardi Dupré 1967, 1978), has met with both accord (Padoa Rizzo 1972, 1992) and skepticism (Bartalini 1990). Although the similarity of type and stylistic treatment in a number of minor figures (see the crowds in the *Meeting of the Queen of Sheba with Solomon* and the *Capture of Jericho*) with the already well-defined manner of Gozzoli's paintings renders the supposition highly plausible in my view, this is not of so much importance as far as the development of Benozzo is concerned as is the

8. Benozzo Gozzoli (?)
Madonna and Child with Nine Angels
30x22,5 cm
London, National Gallery

9. Crucifixion with the Madonna, Saints John, Onophry, Anthony of Padua, Mary Magdalen, and Pious Women
53x37 cm
Paris, private collection

profound assimilation, even interiorization, of the culture of Ghiberti that his continual presence in the workshop of the great sculptor over a period of two years permitted. It was in the artistic and theoretical work of Lorenzo, in fact, that the balanced fusion, in a fertile relationship with Humanism in philosophy and literature, took place between the heritage of International Gothic and the growing influence of classicism, creating an enchanting and unique blend that did not fail to leave its mark on Benozzo. In the same way he was strongly influenced by Ghiberti's empirical approach to perspective, with its differentiated and flexible handling of proximities and distances, combined in an overall harmony that did not necessarily respect the rules of Brunelleschi's *perspectiva artificialis* as formulated by Alberti. Instead, drawing on the subjective medieval Arab point of view, Ghiberti adapted his perspective to the opportunities and necessities of the representation in its guise as a symbolic message and psychological description. Benozzo too — and in this he was following Ghiberti far more than Fra Angelico — was to be the architect of a "graceful mediation" (Morolli 1978) between old and new, between the lively offshoots of the Gothic style and the continual revolutions in artistic language brought about by the age of Humanism.

But let us go back to the works of his juvenile period. For many painters (and Benozzo fits into this broad category) the reconstruction of their early ven-

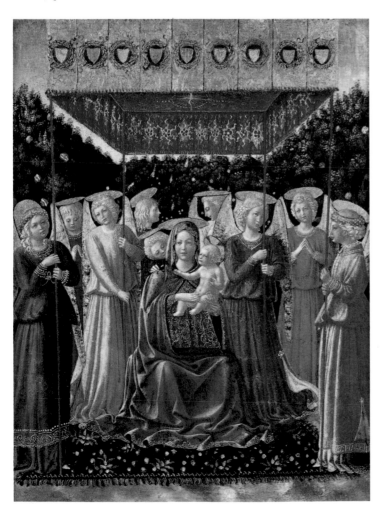

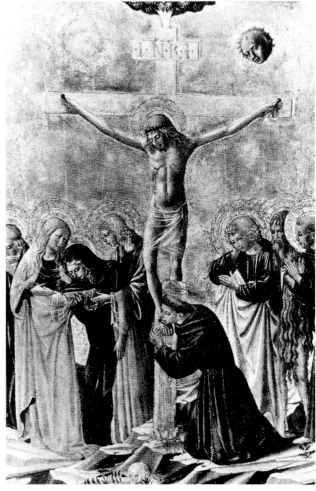

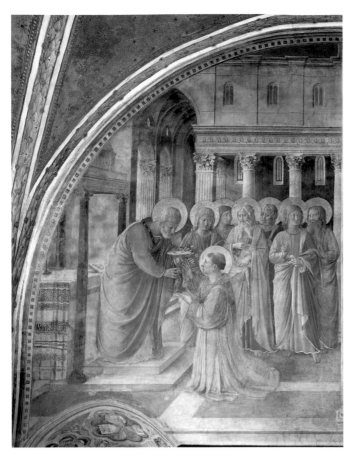

10. Fra Angelico and Benozzo Gozzoli
Ordination of Saint Stephen
Vatican, Nicholas V's Chapel

11. Fra Angelico and Benozzo Gozzoli
*Saint Lawrence before Decius and Martyrdom of
Saint Lawrence*
Vatican, Nicholas V's Chapel

tures into art presents a variety of difficulties. The artist's style is still influenced by that of his master or of an older companion, so that it appears imitative and labored. If the artist, endowed with a lively curiosity, experiments temporarily with the style of other masters, he produces works that are destined to oscillate, in critical interpretation, from one attribution to another. This is what has happened with a very small group, consisting of just two pictures, that critics have most recently tended to assign to Benozzo as youthful works painted under the influence of Fra Angelico (Bartalini 1990, Padoa Rizzo 1992, with references to the previous bibliography), but that present, in their undeniable mutual stylistic consistency that is indicative of an embryonic corpus, points of divergence from the artistic style of the youthful and firmly "Angelican" Gozzoli. This is clearly to be seen in the *Crucifixion* in a private collection in Paris (Longhi 1960), the only work that, in my view, can be definitely assigned to this nebulous pre-Roman and proto-Umbrian phase in Benozzo's career. The *Madonna and Child with Nine Angels* in the National Gallery in London, which has a long and fluctuating history of attribution, having been ascribed in the twenties to Fra Angelico, then to Giovanni Boccati, Domenico Veneziano, and finally, with greater conviction, to Benozzo prior to 1447, is a work of undoubted quality. In this fine painting, where the haloed bodies of the angels divide up the space framed by the tripartite bower of greenery and the red and gold canopy into a sequence of vivid colors, the Madonna is seated amidst the clean-cut folds of a cloak of ultramarine blue. In the luminous transparency of the picture, the flesh tones gleam, the subtly hatched highlights of the fabrics shine, and the locks of the angels glitter like spun gold. The chubby forms of the childish faces, contrasting with the soft hands and limp fingers, together with

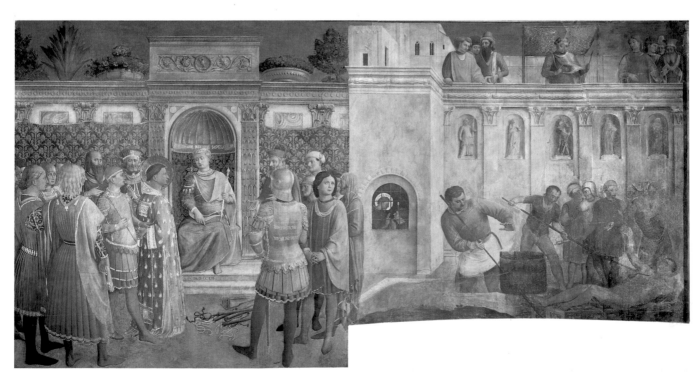

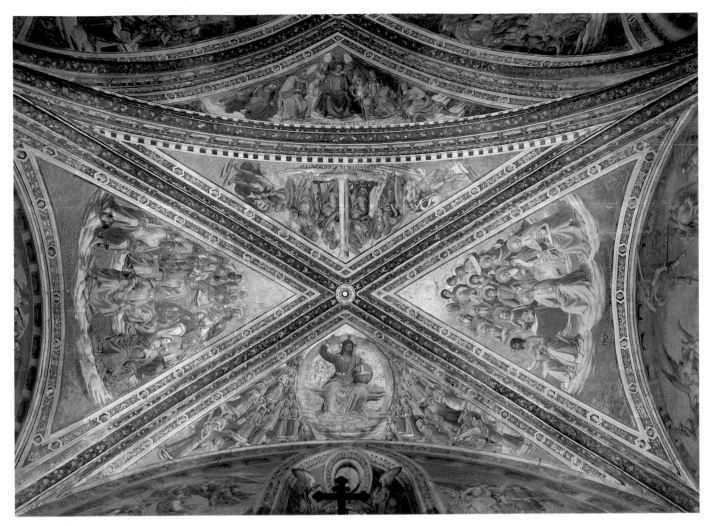

12. Fra Angelico and Benozzo Gozzoli
Vault of the Chapel of San Brizio
Orvieto, Cathedral

many other details (including the strip of mottled marble flooring under the carpet of flowers), are well-suited to a painter strongly influenced by Fra Angelico, but inclined to embellish on the friar's style to the point of languidness, but not to the concrete and almost harsh Benozzo of the Parisian *Crucifixion*, another early work. Even the pattern of the haloes in the picture in London, esteemed for its subtlety of perspective (Bartalini 1990, p. 117), produces a sophisticated effect that is largely absent from his other paintings with groups of angels or saints, in which he, remaining strictly faithful to a motif of Fra Angelico, constantly opts for a frontal view of the haloes (even at the cost of detracting from the faces and heads by obscuring them), and foreshortens one or at the most two of the haloes. We are obliged to posit, in order to maintain the attribution of the London painting to him, a Benozzo strongly influenced by experiences that were parallel to, but outside his usual poles of reference, Angelico and Ghiberti. These influences may have come from Domenico Veneziano, present in Florence from 1439 on, and the early Piero della Francesca. Similar influences, together with classical fantasies in-

spired by a widespread fascination with antique chests, seem to me to be behind the *Abduction of Helen* in the National Gallery in London, which the latest studies have added to the corpus of Benozzo. Elegant in its details but with a stiff overall composition, largely due to the mechanical juxtaposition of static poses and agitated gestures, almost those of a frenzied dance, the small octagonal painting is a real rarity for Benozzo owing to its profane mythological subject. This would presuppose an active involvement with the artistic and craft workshops specializing in painted chests and coffers; something that, if added to his work as a painter with Fra Angelico, on the cleaning up of Ghiberti's casts, and as an illuminator in the unique London manuscript, presents an unlikely image of the range of Gozzoli's proven experimentalism. One of the problems of this early phase in his career is the question of whether he collaborated on the tondo depicting the *Adoration of the Magi* in the National Gallery in Washington (formerly in the Cook Collection). It has been suggested that this was commissioned by Cosimo de' Medici, and is in fact the "large tondo [...] depicting Our Lady and the Lord and the Magi going to make their offerings, painted by Fra Giovanni" that used to be in the summer chamber of Lorenzo il Magnifico in Palazzo Medici. Filippo Lippi was originally believed to have been responsible for the part of this *Adoration* by Fra Angelico that was

9

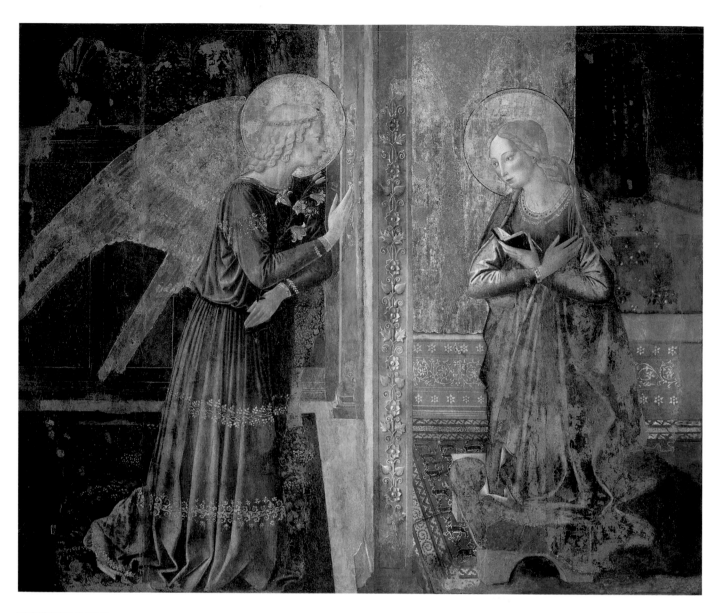

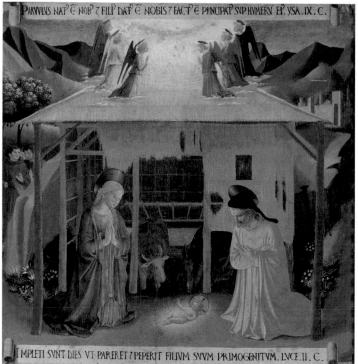

13. *Annunciation*
120x140 cm
Narni, Pinacoteca Comunale

14. *Fra Angelico and Benozzo Gozzoli*
Nativity on the Silverware Cabinet
39x37 cm
Florence, San Marco

painted by a collaborator. However, the similarities with the style of Benozzo (Bellosi in *Pittura di Luce*, 1990, pp. 44-5), and the unlikeliness of Lippi having finished a work started and perhaps left incomplete by Fra Angelico (when logic dictates that it would have been done by someone in the studio) justify an attribution of some of the minor figures to Benozzo, although under the influence of Filippo Lippi's style. Another youthful work of Benozzo's may be the *Saint Nicholas and Three Girls* (sold by Sotheby's in London on June 14, 1961, no. 33), with its exquisite clarity in the manner of Fra Angelico.

Gozzoli's first sally out of the Florentine environment was the result of an opportunity of unique importance. Collaborating once again with Fra Angelico, Benozzo left the Ghiberti workshop before his contract was up and went to Rome, where Angelico had been summoned by Eugenius IV to fresco a chapel in the Vatican (probably that of the Sacrament) at the beginning of 1447. He went on to paint in the chapel of his successor Nicholas V and elsewhere, until June 1448. It is not known, and impossible to reconstruct with certainty, the division of tasks in the large group headed by Fra Giovanni, which included, along with Gozzoli, a number of mere assistants or *garzoni* of various origins: the friar's nephew Giovanni di Antonio della Cecca di Mugello, Giacomo d'Antonio da Poli, Pietro Jacomo da Forlì, and perhaps Carlo di Ser Lazzaro da Narni. Benozzo seems to have been responsible for the decorative parts of the basement and the splays of the windows (Padoa Rizzo 1992, p. 34), where his personal style is most evident, and, in the larger scenes, part of the entourage of figures (see for example Decius and the onlookers in the *Martyrdom of Saint Lawrence*). The figures of St Mark the Evangelist, of which there is a drawing in the Musée Condé in Chantilly, and St Matthew the Evangelist, for which there is a study on a folio in the Fitzwilliam Museum in Cambridge, both on the vault, are ascribed to him.

As for the majority of artists of Benozzo's time, the visit to Rome marked a stage of overriding significance in his cultural and professional development. The encounter with the grandiose architecture and sculpture of the ancient world, whose astonishing majesty was not diminished by their ruinous state or concealment amidst the muddle of medieval constructions, together with the discovery of the great basilicas, sanctuaries of art and devotion from the first few centuries of the Christian era, had a profound influence on artists. Like every other visitor and pilgrim, they found themselves caught up in the solemn and magnificent atmosphere, punctuated by ritual events, that was evocatively described by Antonio Paolucci, in his quest for the visual archetypes of a painter of the caliber of Antoniazzo Romano, as "a total spectacle… a religious psychodrama" (Paolucci 1992). In the Papal Curia, the lofty philosophical and artistic Humanism of Leon Battista Alberti and Filarete had created a cultural magnet comparable to that of Medicean Florence in the age of Cosimo, although under the sway of a more charismatic power that (where the

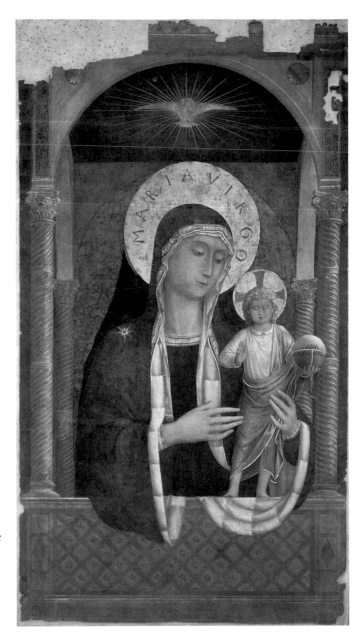

15. Madonna and Child giving Blessings
254x130 cm
Rome, Santa Maria sopra Minerva

shrewd Medici tried not to stand out amongst his fellow citizens) aimed instead at the assertion of its own authority through grandiose works of art. Tangible signs of the influence of antiquity on Benozzo can be seen in his graphic works, as reflected indirectly in the notebook in the Boymans Museum in Rotterdam, produced by the circle of his collaborators for teaching purposes (*circa* 1460): copies made from monuments, sculptures, ornamental details, and epigraphs, forming (together with the drawings, that he had certainly obtained for himself, of the sarcophagi in the Camposanto of Pisa) a treasure house of individual figures and ornaments that was to provide him, over the course of the years, with recurrent citations of a cultivated antiquarian stamp. Nevertheless, however formative, the papal commission and the study of the

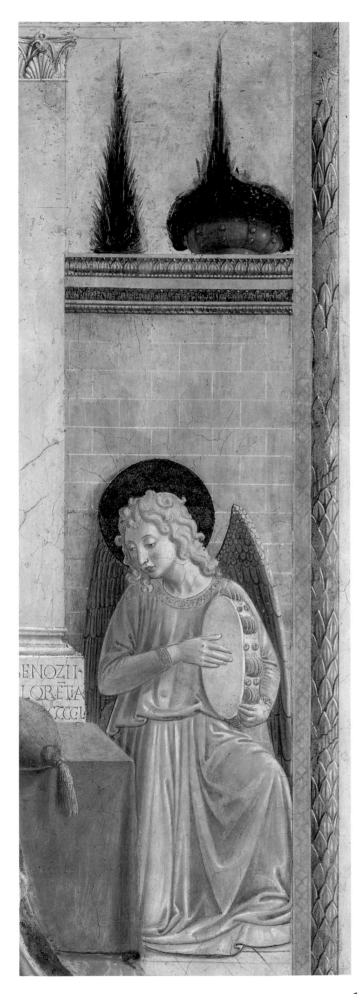

fascinating ancient world did not tie Benozzo to the city. This may have been because, still being subject to the decisions of Fra Angelico to some extent, he did not succeed in establishing independent links with the Curia, but only with the monastic orders (especially the Dominicans, to whom Fra Angelico had introduced him), which recommended him to the great monasteries of the Papal States. Evidence that he did do some work in Rome independently of Angelico comes from two works that have now been lost: the frescoed panel over a door in the Torre dei Conti depicting the *Madonna and Saints*, recorded by Vasari (Padoa Rizzo, 1992, identifies this with the fragment now in the church of Santi Domenico e Sisto, but the subject is somewhat different and it has been convincingly attributed by Bellosi to the young Antoniazzo Romano); and the frescoes also recorded by Vasari in a chapel in Santa Maria Maggiore, which did not survive the restructuring of the church. What does survive however, rendered legible again and with its authorship confirmed after restoration (Pasti 1985), is the painted silk standard for Santa Maria sopra Minerva, the singular fruit of a grafting of the archaic solemnity of early Christian and medieval images, like the ones he had encountered in the Roman churches, onto the highly plastic rootstock of Fra Angelico's Florentine painting. Peering over the parapet of the elegant ciborium in the Gothic style, but with Renaissance proportions, and framed by a dark and heavy cloak, the Madonna gazes tenderly at the Savior. The latter is not represented in the form of a child but as an adult in miniature, solemnly dressed in a tunic and red pallium. The original synthesis of different artistic languages achieved by the painter in this devotional picture, dating from around 1449, leads one to think that a longer stay in Rome would have been of great significance to the development of his artistic style. So we can only regret that he moved away from the vivid influence of antiquity, whether that of Roman classicism or of early Christian and medieval art, first to follow Fra Angelico and then to carry out his own, independent commissions, apart from occasional and brief returns. In June 1447, suffering from the heat of the Roman summer, the friar interrupted his work in the Vatican and, with the most faithful members of his studio, accepted a commission from the superintendents of Orvieto Cathedral, with whom he had come to an agreement the year before, to fresco the chapel of San Brizio. Benozzo's role in the work (which was

16, 18. Madonna Enthroned and Child with Angel playing Music
Montefalco, San Fortunato

17. Madonna and Child between Saints Francis and Bernardine of Siena
Montefalco, San Fortunato

19. Saint Fortunatus Enthroned
Montefalco, San Fortunato

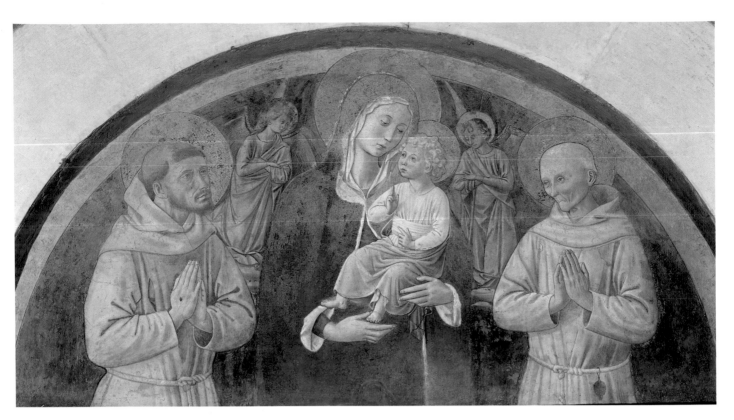

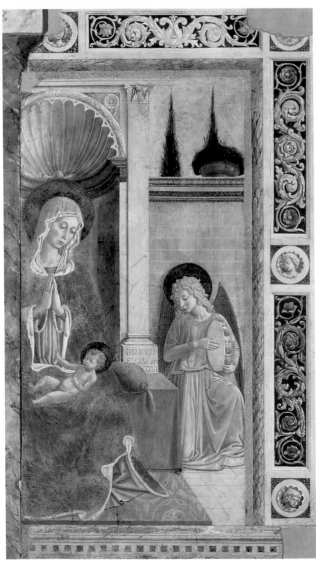

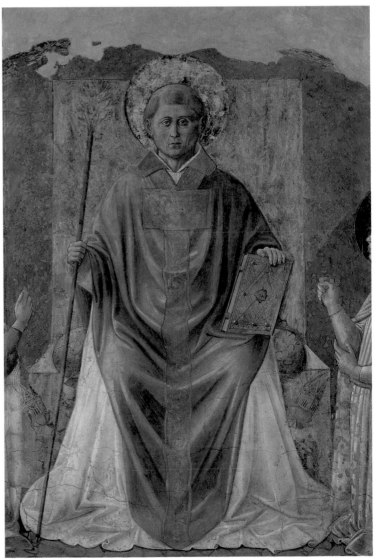

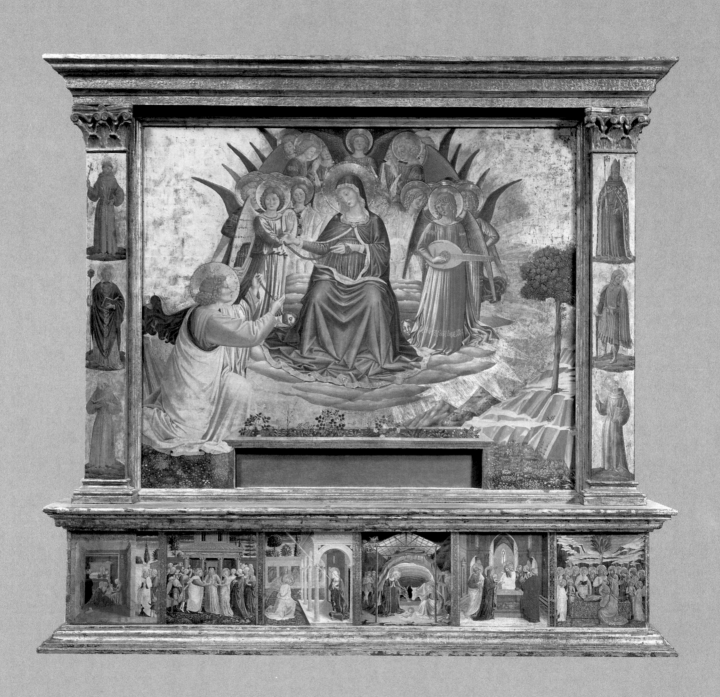

interrupted after the decoration of the great cross vault with *Christ the Judge, Angels, and the Chosen*) is still the subject of debate (De Marchi 1990, p. 102; Padoa Rizzo 1992, p. 32), even though the restoration has restored full legibility to the vaulting cells and the fascias decorated with figured compasses (*La cattedrale...*, 1990). It appears likely, however, that Benozzo painted the decorative borders with heads. Owing to its similarity with these, the splendid drawing of the *Head of a Young Cleric* (Windsor, Royal Library, no. 12812), highlighted in white lead, which some have been tempted to assign to Fra Angelico, could well be attributed definitively to Gozzoli.

In 1450, with the friar's return home to take up the post of prior of Fiesole monastery, Benozzo finally took the grand decision to set himself up on his own (although his collaboration with Fra Angelico did continue a little beyond 1450, painting the *Nativity* for the Silverware Cabinet of Santissima Annunziata in Florence, now in the Museo di San Marco). Staying in Umbria, his reputation among the mendicant orders

20. *Madonna della Cintola*
133x164 cm
Vatican, Pinacoteca

21. *Vault representing Saint Francis in Glory and Saints*
Montefalco, San Francesco

and perhaps the recommendation of Nicholas V obtained him a commission from the Franciscans of Montefalco. These were his first fully independent works. A few other paintings in Umbria seem to predate the Montefalco frescoes: a delicate and precise *Annunciation*, probably originally from a church and now in the Pinacoteca Comunale of Narni; some fragmentary decorations formerly in the church of San Domenico in Foligno, in the Museum of Palazzo Trinci; and a parchment with the *Head of Christ* crowned with thorns, or *Vir dolorum*, now in the Treasury of the Basilica of Assisi. Benozzo's passage through Assisi, documented by this last work, is of particular significance not only because it demonstrates the strength of his relationship with the Franciscan order (whose peaceful coexistence with the other great mendicant order, that of the Dominicans, was consistently promoted in Medicean Florence), but also because it proves that he was familiar with Giotto's frescoes. The study of the latter helped to consolidate Gozzoli's profound tie with the tradition of the Florentine Gothic, whose monumental spatiality he was able to revise and rework in up-to-date terms of luminarism and clarity of perspective. A small picture in a private collection in Paris, dated to around 1450 by Roberto Longhi (1960), but to a few years earlier by Padoa Rizzo (1969 and 1992), seems to mark the beginning of the painter's productive relationship with the Franciscans of the hermitage of San Fortunato near Montefalco. In fact it comes from that convent and depicts

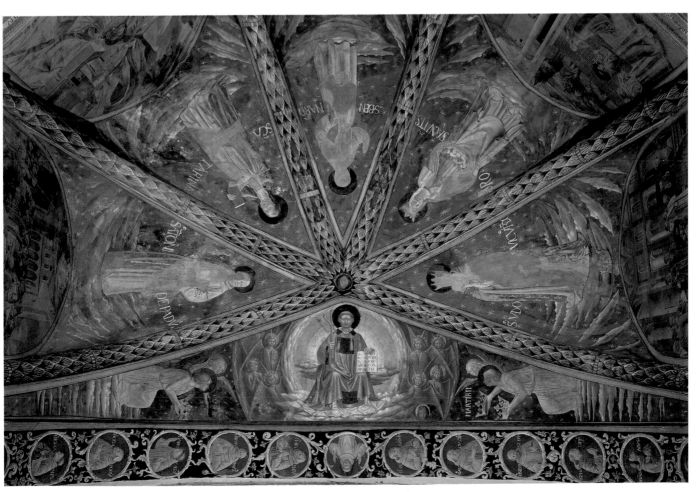

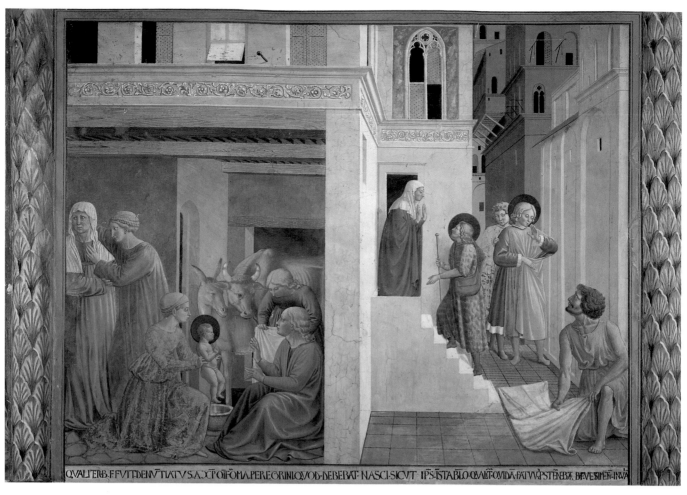

QVALITER B·F·FVIT·DENVTIATVS·A·XPOIFOMA·PEREGRINI·QVOD·DEBEBAT·NASCI·SICVT·IPS·ISTABLO·QVALT·QVIDA·FATVV·PSTENEBA·BEVESTIEN·INVA

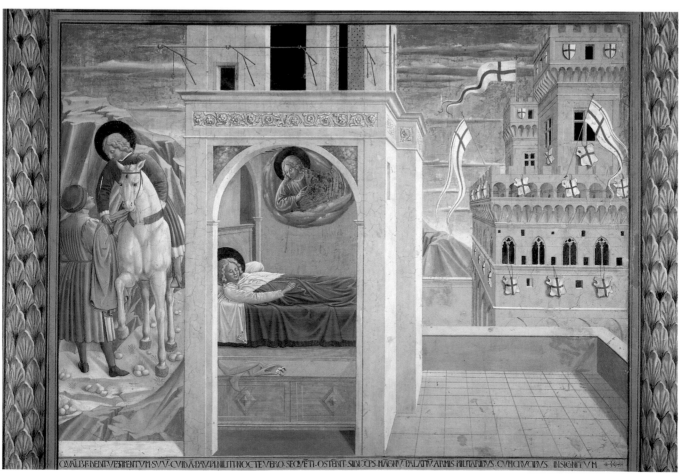

QVAL·B·F·DEDIT·VESTIMENTV·SVV·CVIDA·PAVPI·NILITI·NOCTE·VERO·SEQVE·TI·OSTENT·SIBI·CPS·MAGNV·PALATIV·ARMIS·MILITARIBVS·CVM·CHCVCIVS·INSIGNITVM

16

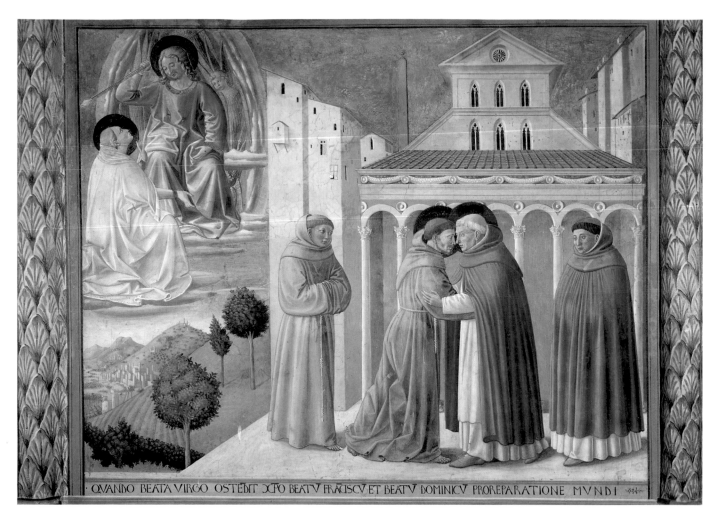

· QVANDO · BEATA VIRGO · OSTEDIT · XPO · BEATV · FRACISCV · ET · BEATV · DOMINICV · PROREPARATIONE · MVNDI ·

22. Birth of Saint Francis and Homage of the Simple Man
Montefalco, San Francesco

23. Saint Francis giving away His Clothes and the Vision of the Church Militant and Triumphant
Montefalco, San Francesco

24. Meeting of Saint Francis and Saint Dominic
Montefalco, San Francesco

the *Crucifixion with the Madonna, Saints John, Onophry, Anthony of Padua, Mary Magdalen, and Pious Women*; thus the subject was suited to the Franciscan order by the inclusion of St Anthony, and to the hermitage by that of St Onophry. It is a work that, notwithstanding its small size and subsequent further reduction, achieves an effect of tragic monumentality.

The mural paintings executed by Benozzo in the church of San Fortunato (one of which is dated 1450) form a cycle of considerable importance, but one that has unfortunately come down to us in a fragmentary state. All that survive, in fact, are a lunette over a door with the *Madonna and Child between Saints Francis and Bernardine of Siena*, surmounted by *Seven Archangels*; a *Madonna Enthroned adoring the Child* among angels playing music, of which little more than the right-hand half is left; and a *Saint Fortunatus Enthroned* full of gaps, on the second altar on the right. The master of an expanded and airy style, which reaches an extraordinary psychological intensity in the grave patron saint with his miraculous rod clearly visible, Benozzo completed the pictorial renovation of the church with the picture on the high altar. The rectangular altarpiece, with pillars and predella, depicts the *Madonna della Cintola* in an arc of angels; on the pillars are the figures of Saints Francis, Fortunatus, Anthony of Padua, Louis of France, perhaps Julian, and Bernardine of Siena; the six small scenes in the predella are devoted to the life of the Virgin Mary, from the *Nativity* to the *Dormitio*. Donated by the inhabitants of the town to Pius IX, the painting is now in the Pinacoteca Vaticana. Benozzo's debt to Fra Angelico, his unforgotten partner and master, was still great: and yet the breadth of the distribution of masses, the festive and decisive juxtaposition of tints (with red and blue predominating), the depth of the landscape set against the glitter of the gold background, and even such a delightful decorative digression as the pointed crown of angel's wings around the Madonna all serve to demonstrate the degree of independence of invention and composition that he had achieved. But Benozzo's great opportunity was to come with the commission that followed immediately afterward, once again from the Franciscans, to decorate the apse of the Gothic church of San Francesco at Montefalco with *Scenes from the Life of Saint Francis*. The cycle,

17

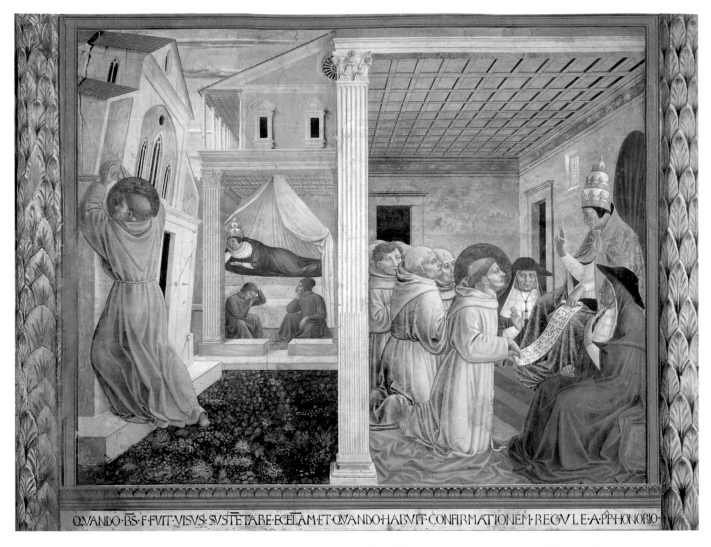

QVANDO·BS·F·FVIT·VISVS·SVSTETARE·ECELAM·ET·QVANDO·HABVIT·CONFIRMATIONEM·REGVLE·A·PP·HONORIO·

dated 1452, bears the painter's signature (BENOTIUS FLORENTINUS) and the name of the client, the prior Fra Jacopo da Montefalco. The architectural structure of the polygonal apse on a pentagonal plan, covered by a ribbed umbrella vault, obliged Benozzo to make use of an extremely Gothic division of the cycle, which threatened to place limits on his expressiveness. And in fact, while the five Franciscan saints Louis, Rose of Viterbo, Bernardine of Siena, Catherine, and Anthony of Padua fit in nicely, one to each segment, with their backdrop of a starry sky and support of rose-colored clouds, the solid *Saint Francis* seated in glory is almost squashed into the segment bordering on the underside of the arch, with a sculptural force that spills over into the blazing circle of seraphim, "cut" by the triangular field. His secure grasp of the spatial layout is demonstrated by the foreshortening of the cross in the saint's hand. In the twelve scenes from the life of St Francis on the walls, arranged in a series of bands and lunettes, Benozzo found room for an expansive, original narration. In the episodes urban backdrops alternate or coexist with rural ones, resulting, in both cases, in the construction of perspective views that are perhaps not impeccable, but clear and carefully executed: distinct interlockings of stereometric volumes in the first case, and of expanses of trees, fields, or meadows in the second. Particularly effective, owing

25. The Dream of Innocent III and the Confirmation of the Rule
Montefalco, San Francesco

26. The Expulsion of the Devils from Arezzo
Montefalco, San Francesco

to the complexity of the architectural layout and the pattern of light and shade produced by the interior lighting, is the intriguing longitudinal view of the church that forms the setting for the *Greccio Manger*, Gothic in structure but updated to match Renaissance sensibilities by the two rows of fluted pilasters. In the *Expulsion of the Devils from Arezzo* and the *Dream of Innocent III*, Benozzo attempted an almost touching translation of fourteenth-century artistic language into the new perspective-based visualization bathed in light. These took their inspiration from the corresponding scenes in Giotto's cycle in Assisi, perhaps proposed by the clients themselves as an unsurpassed archetype of Franciscan narration. The organization of the cycle into rows and panels that blend with the architecture is underlined by borders on the underside of the arch and at the base, of a highly ornamental character. On the underside of the arch the decorations include portraits of blessed or at least well-known

18

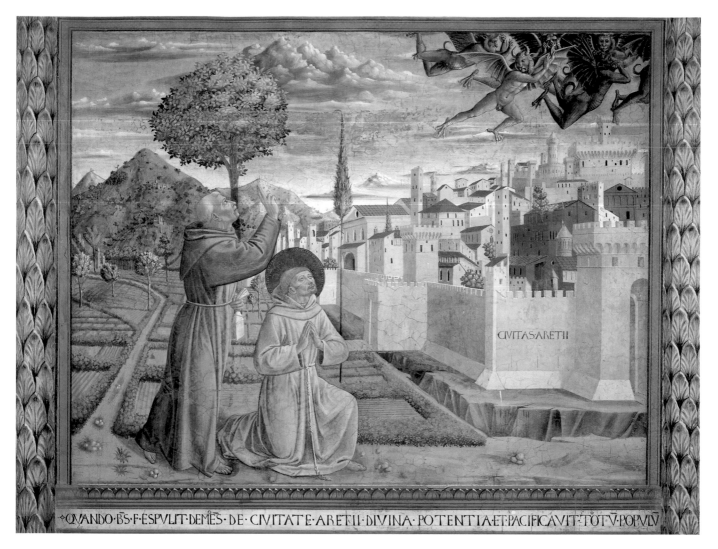

QVANDO·BS·F·ESPVLIT·DEMES·DE·CIVITATE·ARETII·DIVINA·POTENTIA·ET·PACIFICAVIT·TOTV·POPVLV

Franciscans, and, in the fascia at the base, of famous men, a typically Humanistic feature. Among them are Francesco Petrarch, Giotto, and Dante. The latter is described as "THEOLOGVS" in the inscription in capital letters that accompanies his portrait, like the others, and is strangely represented in a frontal pose, instead of in three-quarters or profile as was the tradition in the fourteenth and fifteenth centuries.

The same church contains another work by Benozzo, though one that has been slightly reduced in size: the mural decoration of the chapel of San Girolamo. This consists of the *Evangelists* on the vault, a mock altarpiece with panels painted on the altar wall, with *Scenes from the Life of Saint Jerome* at the sides and a *Crucifixion and Saints* at the top, and a *Christ blessing with Saints and Angels* in the entrance archway. The most memorable painting in the chapel is undoubtedly the polyptych, executed with meticulous illusionism (note the long shadows). The painter has enclosed the image, with its Gothic structure of spires and pinnacles, in a frame in the antique style, and therefore of "modern" form, in a combination of the old and new that was not uncommon in certain artful updatings of altarpieces that had gone out of fashion, but were still dear to the descendants of the original clients (examples can be found in the catalogue *Maestri e botteghe*, 1992). Like the "Renaissancized"

Gothic church of the *Greccio Manger*, this imaginary polyptych shows that Benozzo had a shrewd and subtle sense of history, viewed through the alteration of forms. And in the light of this rare sensibility of his, instead of considering him a Gothic artist reluctant to accept the advent of the figurative culture of the age of Humanism, we would do better to see him as the depository of different stylistic languages, capable of mastering and combining them in the full knowledge of their chronological sequence; and as an artist who was not without a hidden trait of acuteness in this ability to reveal, and reproduce *in vitro*, the evolutionary mechanisms of the history of style in these original combinations of images taken from different eras.

The mural paintings of San Francesco in Montefalco, on the whole well preserved and recently restored, provide evidence of Benozzo's growing sense of personal achievement. As well as signing and dating the paintings, he gave expression to his pride in the Latin hexameter "QVALIS SIT PICTOR PREFATVS INSPICE LECTOR." From 1450-2 onward the demand for works of art and figurative cycles from Benozzo intensified, and once again his clients were the Franciscans. The small picture in the National Gallery in Washington, depicting *Saint Ursula* and the Franciscan nun Ginevra, is believed to come from Montefalco, but the similarity of the faces with those executed

19

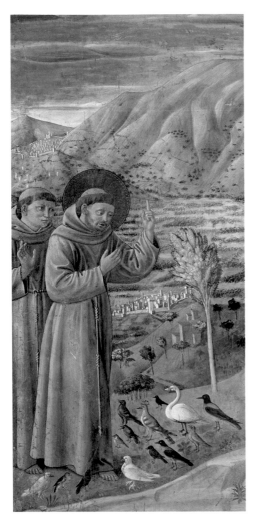

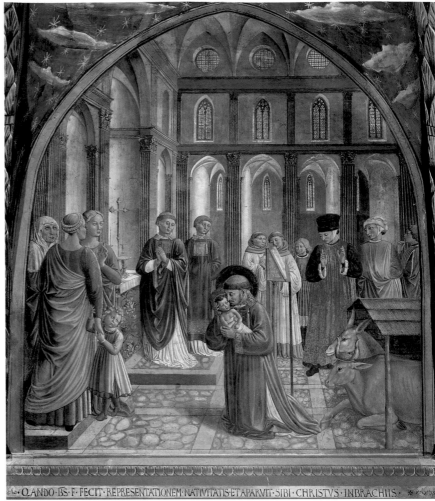

QANDO·BS·F·FECIT·REPRESENTATIONEM·NATIVITATIS·ETAPARVIT·SIBI·CHRISTVS·INBRACHIIS·

by assistants in the Pisa period suggests that it should be given a later date. Of a much higher quality, on the other hand, is the *Madonna and Child with Saints Francis and Bernardine and Fra Jacopo* in the Kunsthistorisches Museum of Vienna. The Madonna is resplendent amidst gold, red, and pale vair, against a backdrop that appears to be a nighttime view of a wood, although checks need to be made to see if there has been any alteration in the pigments or binders of the greens. In 1543 Benozzo was in Viterbo, where he had been summoned to paint ten scenes from the life of the patron saint in the church of the Franciscan nuns of St Rose. Unfortunately these were lost in the restructuring carried out in 1652. All that remains, as a pale and indirect testimony, are the watercolor copies made by a painter from Orvieto, Francesco Sabatini, prior to their destruction. To this important phase in the maturation of Benozzo, who was now enriching the style he had learned from Fra Angelico with elements of the more recent "painting of light" from Florence and elsewhere, belongs the *Madonna and Child with Saints John the Baptist, Peter, Jerome, and Paul* in the Galleria Nazionale dell'Umbria in Perugia. The painting was commissioned by the Bishop of Recanati, Benedetto Guidalotti for the chapel of the college of San Girolamo in his native city. Signed and dated 1456, the altarpiece with pillars and predella maintains close ties with the Gothic tradi-

27. Preaching to the Birds and Blessing to the Consuls of Bevagna and Montefalco, detail
Montefalco, San Francesco

28. Establishment of the Manger at Greccio
Montefalco, San Francesco

29. View of the wall of the Chapel of San Girolamo with scenes from the lives of Christ and Saint Jerome
Montefalco, San Francesco

tion in the stately splendor of the gold background, but the figures bathed in strong light, set firmly in space by virtue of their forceful drapery, are contemporary in style, with the intriguing result that we can now see to be typical of Benozzo's work in this period.

Between 1456 and 1459 Benozzo put in an irregular appearance in various places in Central Italy. At Sermoneta he painted a *Madonna* crowned by nine choirs of angels for the cathedral, an evident reworking of a much more archaic, cuspidate composition. He was in Rome in 1458, working on the displays for the coronation ceremony of Pius II, where he also frescoed the Albertoni chapel in Santa Maria d'Aracoeli, of which a *Saint Anthony of Padua* between the client and his wife survives.

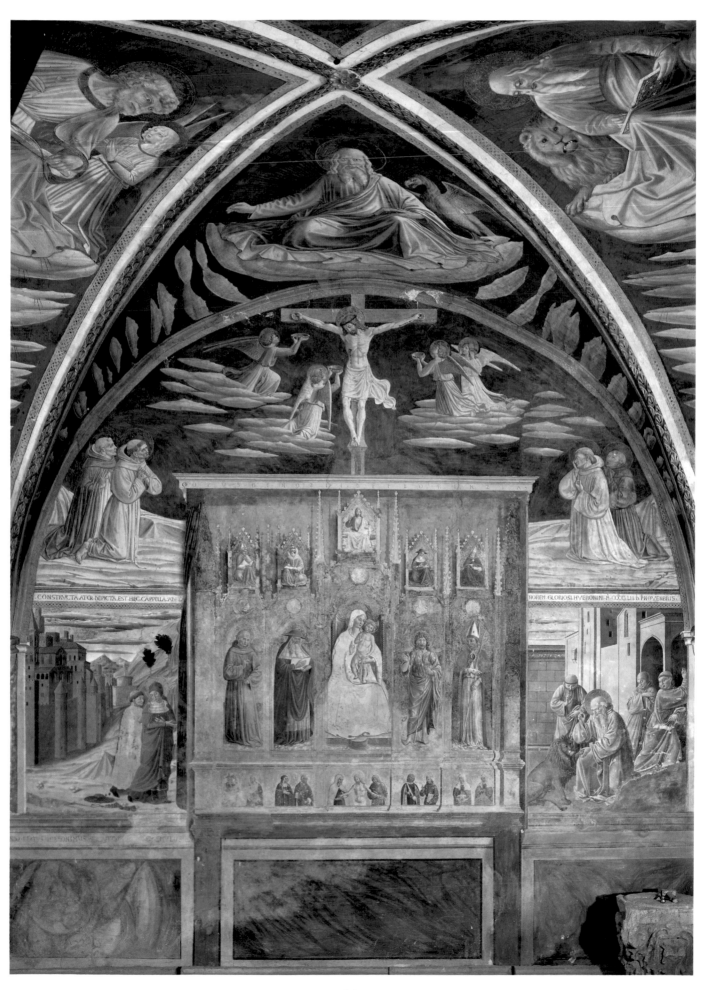

21

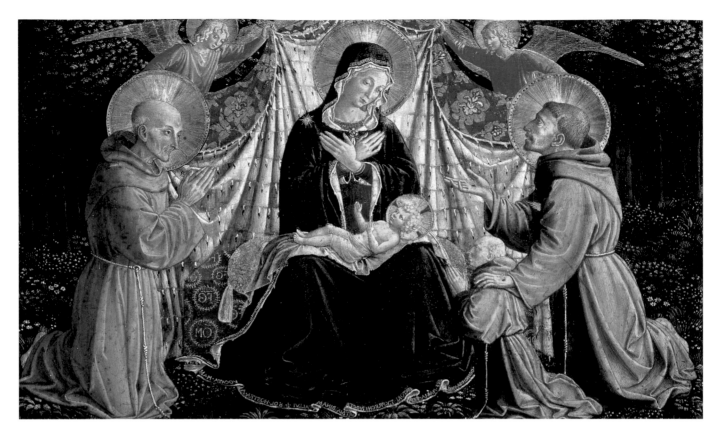

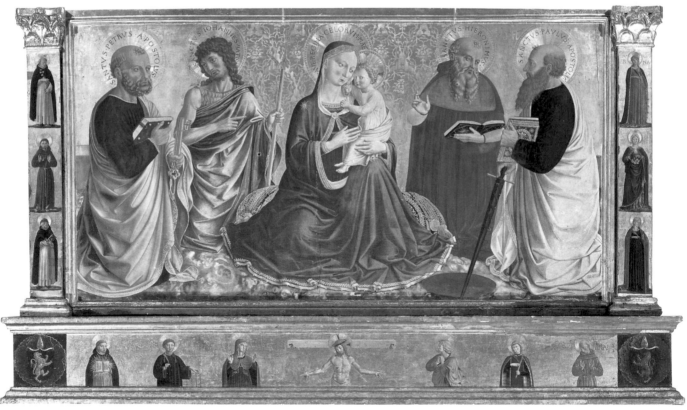

30. *Madonna and Child with Saints Francis and*
Bernardine and Fra Jacopo
34x54 cm
Vienna, Kunsthistorisches Museum

31. *Madonna and Child with Saints John the*
Baptist, Peter, Jerome, and Paul
122x212 cm
Perugia, Galleria Nazionale dell'Umbria

22

Benozzo must have gone back from time to time to Florence, where he was summoned in 1459 by the city's most illustrious patrons, the Medici, to carry out the prestigious commission of decorating the walls of the chapel in their palace on Via Larga. This, with its refined architectural structure, its wooden ceiling with roses gleaming with gold and colors, and its inlaid floor of ancient marbles, had just been completed under the supervision of the architect Michelozzo di Bartolommeo.

It is perfectly logical that for their private temple, the sacred heart of the palace but also the location for audiences and political meetings (Galeazzo Maria Sforza, son of the duke of Milan, had been received there in April 1459), Cosimo de' Medici chose not one of the many outstanding painters in the city, but the marginal Benozzo, the right-hand man of his trusted painter Giovanni Angelico and whose work he had already seen in San Marco. The assignment of the chapel's altarpiece depicting the *Adoration of the Child* to Filippo Lippi had fallen through, perhaps because Lippi had too many engagements in Prato. In any case, few painters would have been able to satisfy Cosimo's desire to see a sacred subject represented in a setting of ceremonial and worldly pomp, or so willing to meet the Medicean demand for magnificence as to antedate their own artistic style in order to compete, at a distance of thirty years, with the fabulous splendor of the *Adoration of the Magi* commissioned from Gentile da Fabriano by the family's never-forgiven enemy Palla Strozzi, and to surpass it once and for all. The pictorial decoration of the walls, to which the *Lamb* of the Apocalypse over the door serves as a solemn *introibo*, is subdivided between the two rooms of the chapel. The hall is devoted to the *Journey of the Magi* from Jerusalem, the white walled city at top right, to Bethlehem, the place of Jesus's *Nativity* celebrated in the altarpiece. On the narrow strips of wall above the entrances of the two small sacristies, at the sides of the rectangular apse, is depicted the *Vigil of the Shepherds* in the dusk before the Holy Night; while on the side walls of the apse we find the *Angels* rushing from Heaven, as we are informed in the Gospel according to Luke, to worship Christ. Finally, on the much disturbed altar wall (in which a large window was opened in 1837, only to be closed again in 1921), remain two of the symbols of the *Evangelists* painted by Benozzo, the Eagle of John and the Angel of Matthew. At the heart of its religious significance, the extremely carefully studied iconography of the chapel alludes to three sublime offerings made to the Redeemer: the gifts of the Wise Men, the prayers of the angels, and the love of Mary, which the faithful are invited to imitate by offering their own tribute of devotion by heart, word, and deed (Acidini Luchinat 1993). But on the descriptive and narrative plane, Gozzoli's elaborate compositions depict the event related in the Gospel in terms of chivalrous splendor (certainly at the clients' request). Thus to the already rich and fabulous tradition of the representations of the "three Kings" in painting and drama, Benozzo adds unprecedented elements of refinement, comparable, in their technical effort and search for preciosity in every detail, to great miniatures. The triple procession of the kings, composed according to the rules of an exact protocol, parades across the walls, along with a scene of noblemen hunting with hawks, dogs, and cheetahs in the Turkish manner. The royal bands are followed and preceded by two groups of citizens on horseback and foot: on the right can be seen members of the Medici family, including Cosimo, Piero, the children Lorenzo and Giuliano, and perhaps Carlo and Giovanni, together with a self-portrait of Benozzo; on the left Benozzo again (perhaps even twice) and a group of supporters or agents of the Medici, such as Bernardo Giugni, Francesco Sassetti, Agnolo Tani, and perhaps Dietisalvi Neroni and Luca Pitti, who were to become enemies in 1466. In the apse the ranks of angels, with marvelously ornate clothes and wings, are depicted in the act of flying, singing, worshiping on their knees, and weaving festoons of flowers; the verses inscribed in their haloes tell us that the hymn they are intoning is the *Gloria*.

Having begun the work in the spring-summer of 1459, Benozzo completed the work rapidly over the space of a few months, with the help of at least one assistant (probably Giovanni di Mugello), under the supervision of Piero di Cosimo de' Medici or his friend and confidant Roberto Martelli. From their correspondence we learn that Piero did not like the little red heads of the seraphim at the top of the rectangular apse; but, perhaps through Martelli's intercession, the painter was allowed to retain them. The recent restoration (1988-92) has brought to light two blue cherubim in those upper levels of the sky, painted in the same precious ultramarine blue as the background, made of ground lapis-lazuli, which had been covered up by a seventeenth-century repainting. The extraordinary complexity and subtlety of the technique of execution, in which true fresco alternated with dry fresco, permitted the painter to work with meticulous care, almost as if he was engraving, like the goldsmith he had been in Ghiberti's workshop, not just the precious materials of jewelry, fabrics, and harnesses, but even the trees laden with fruit, the meadows spangled with flowers, the variegated plumage of the birds, and the multicolored wings of the angels. Finally, leaves of pure gold were applied generously to shine in the dark, in the dim light of the candles. The modifications made by the Riccardi (owners of the palace after the Medici), have distorted the original symmetry of the small room, but have taken nothing away from its magical splendor, now brought back to life by restoration. It is the greatest testimony to the art of Benozzo, here the unsurpassed interpreter of the aristocratic aspirations of the Medici, to which he gave figurative expression by blending, in accordance with a now tried and tested formula, the ornamental legacy of the recent Gothic past with the new grasp of perspective, all set in the transparency of the clear and revealing light imported from Flanders.

During his stay in Florence, which lasted until 1463,

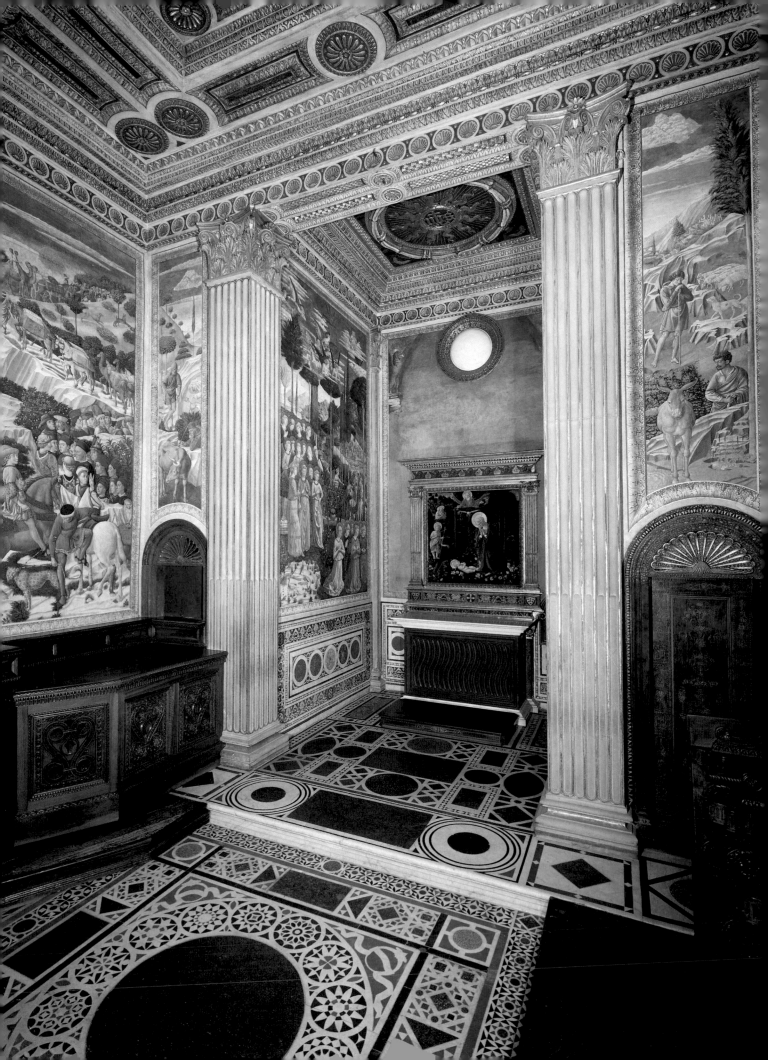

32. *View of the Chapel of the Magi*
Florence, Palazzo Medici Riccardi

33, 34. *The Vigil of the Shepherds*
Florence, Palazzo Medici Riccardi

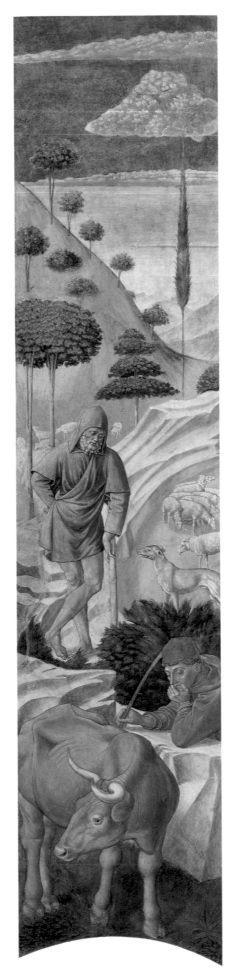

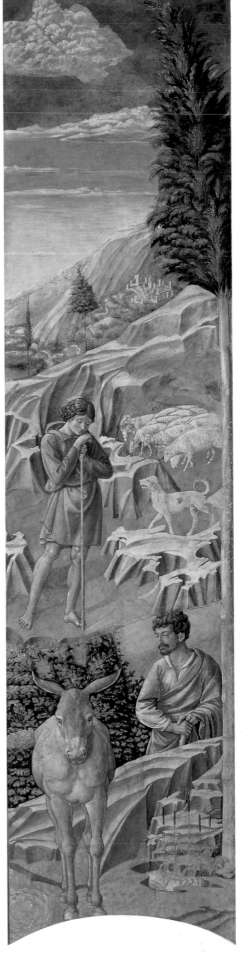

35. *Angels worshipping, left wall of the rectangular apse*
Florence, Palazzo Medici Riccardi

36. *Angels worshipping, right wall of the rectangular apse*
Florence, Palazzo Medici Riccardi

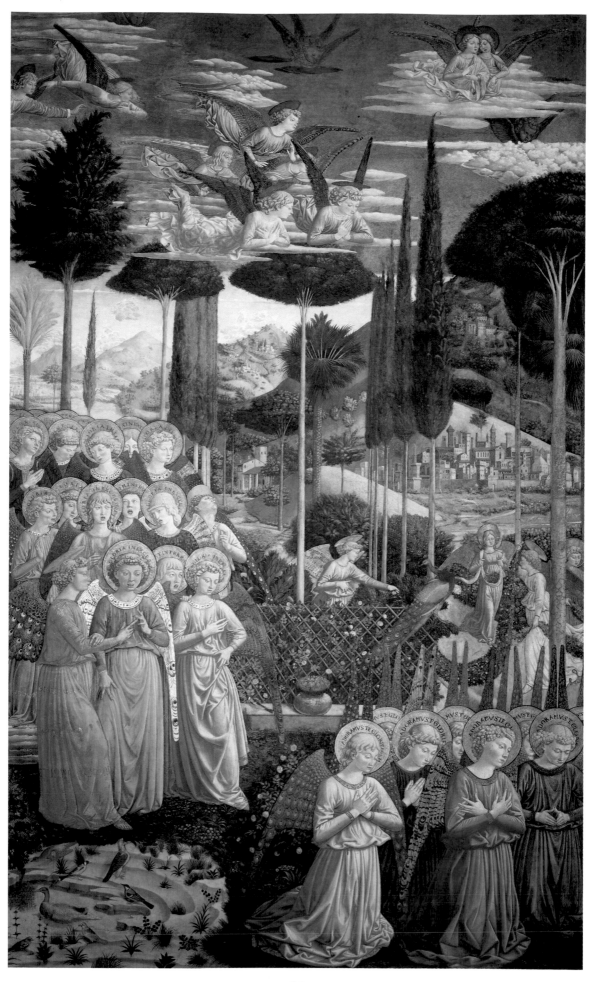

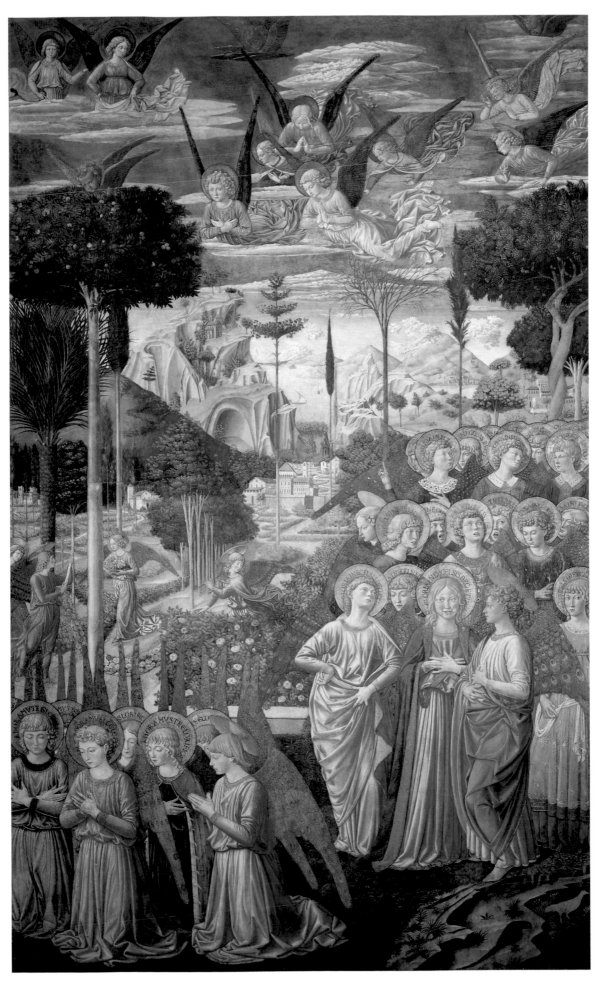

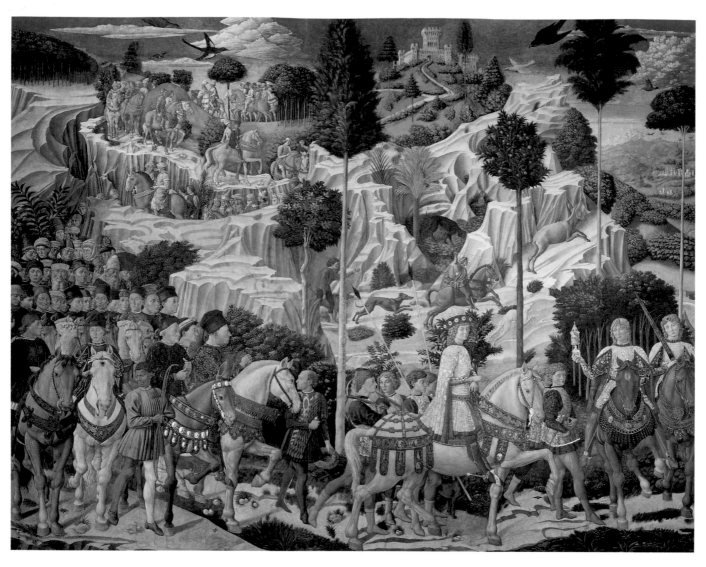

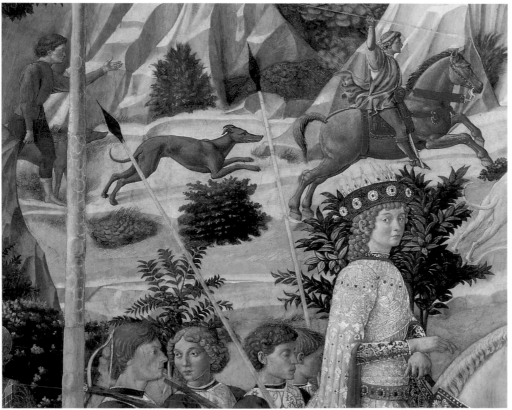

*37-39. Procession of
the Magus Gaspar on
the right wall of the
Chapel
Florence, Palazzo Medici
Riccardi*

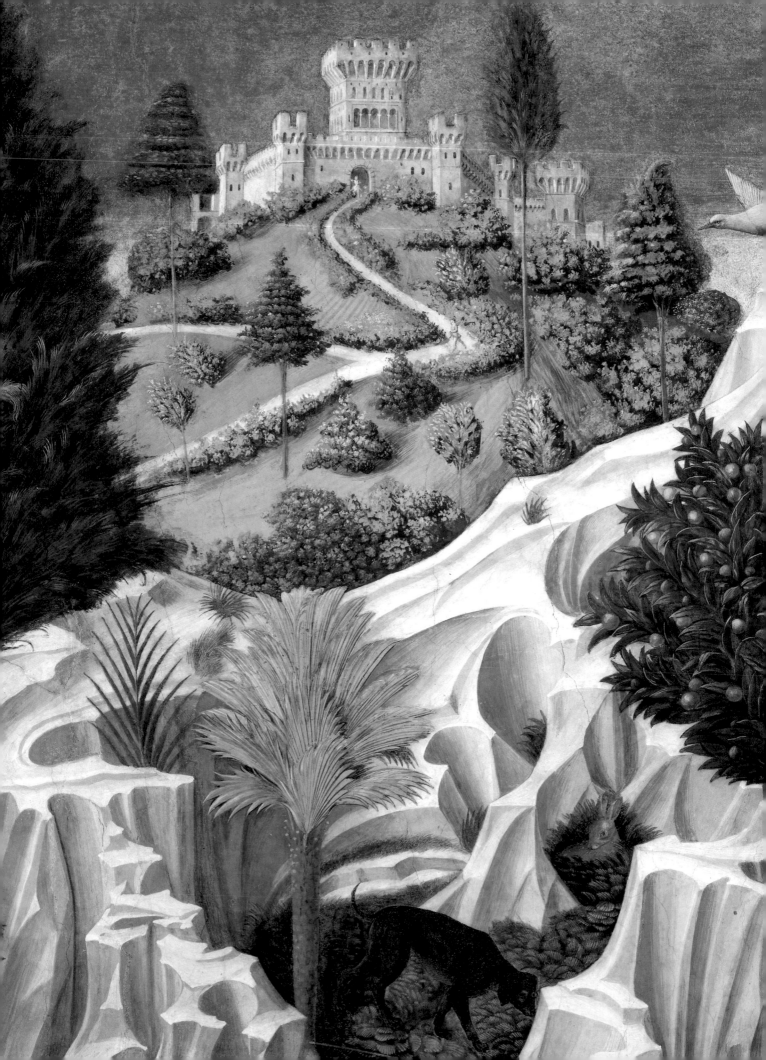

40. *Detail of the procession of the Magus Gaspar Florence, Palazzo Medici Riccardi*

41. *Procession of the Magus Balthazar on the entrance wall of the Chapel Florence, Palazzo Medici Riccardi*

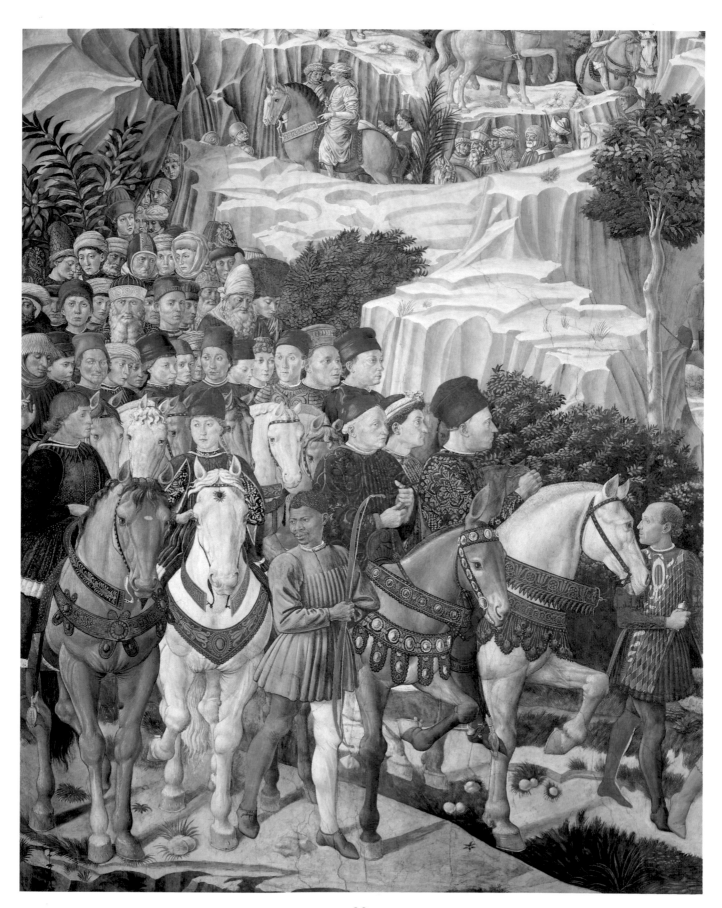

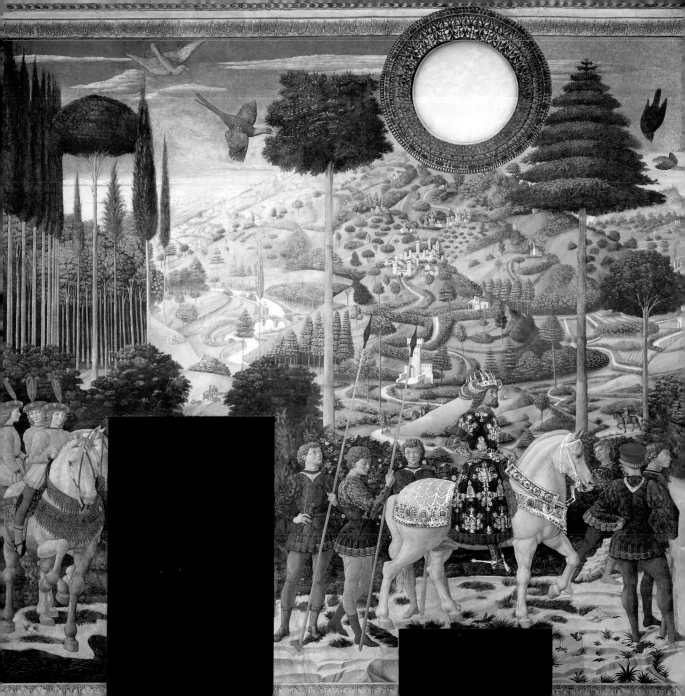

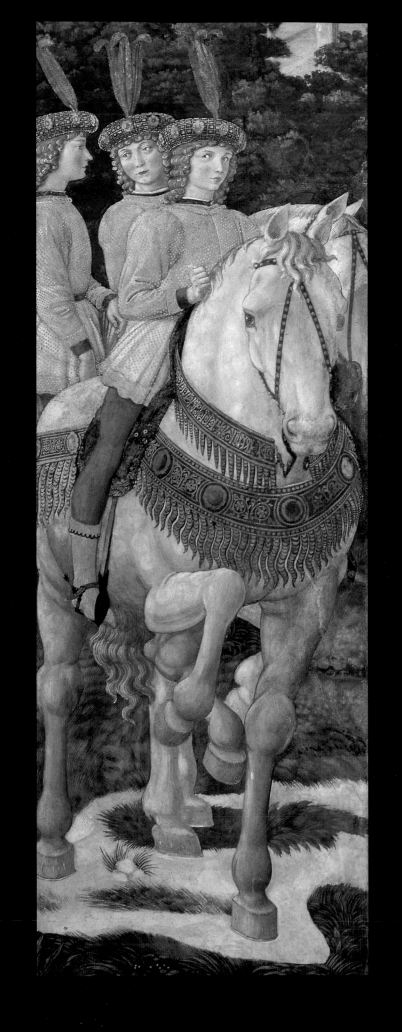

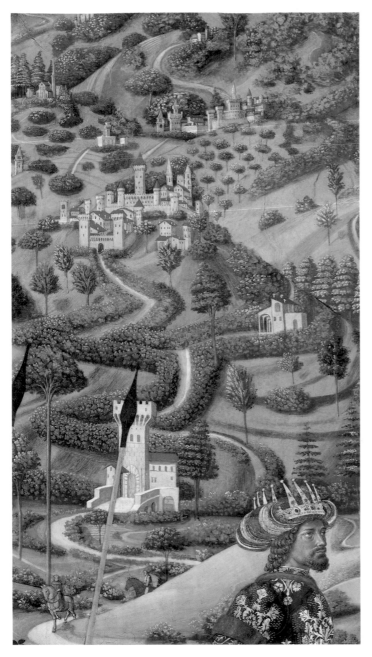

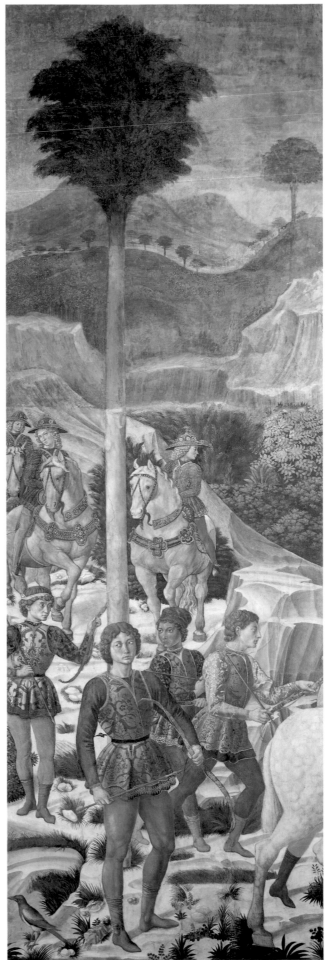

42. Detail of the procession of the Magus Gaspar
Florence, Palazzo Medici Riccardi

43. Landscape behind the Magus Balthazar
Florence, Palazzo Medici Riccardi

44. Backfill wall of the procession of the Magus
Melchior
Florence, Palazzo Medici Riccardi

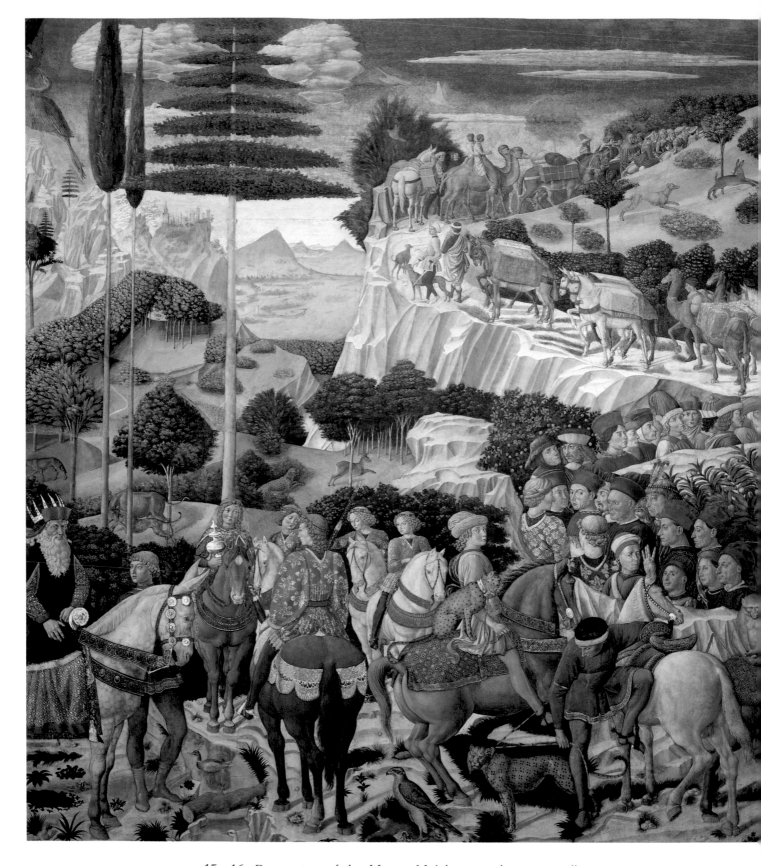

45, 46. Procession of the Magus Melchior on the west wall
Florence, Palazzo Medici Riccardi

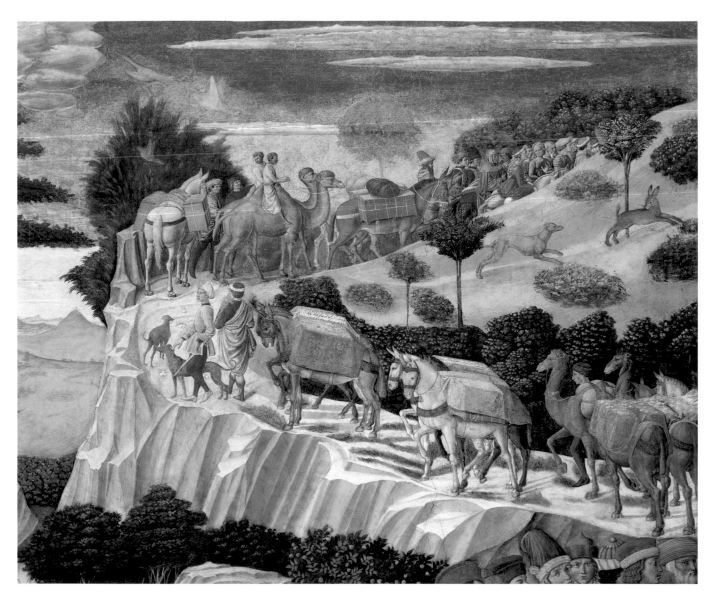

Gozzoli received a number of other important commissions. His contract with the Compagnia della Purificazione at San Marco (a convent known to have been under the patronage of the Medici) for the execution of an altarpiece with predella, in an elaborate frame, that may have been started but left unfinished by Domenico di Michelino, dates from October 23, 1461. The important painting, which according to the terms of the contract had to be finished by 1462, was dismembered on the suppression of the confraternity and its various elements dispersed. The panel with the *Madonna and Child* among Saints John the Baptist, Zanobius, Jerome, Peter, Dominic, and Francis is now in the National Gallery in London; the scenes from the predella are in the Gemäldegalerie in Berlin (*Saint Zanobius raising a Child from the Dead*), the National Gallery in Washington (*The Dance of Salome*), the Pinacoteca di Brera in Milan (*Saint Dominic raising a Child from the Dead*), the Johnson Collection in Philadelphia (*Purification of the Madonna*), and Hampton Court, London (*Fall of Simon Magus*), while the right-hand pillar with three saints is, together with the left-hand one by Domenico di Michelino, in the Galleria dell'Accademia in Florence. Despite their

small format and the intervention of the less gifted assistant of the Chapel of the Magi, believed to be Giovanni di Mugello, the Benozzo panels have some memorably lively features, especially in the evocation of settings and of figures in movement, including the supple and uninhibited *Salome*. In the altarpiece in London, the brilliant colors and the high degree of embellishment with gold do not make up for the rigidity of the motionless figures or the affectedness of the small garden that blooms at the foot of the throne; two birds taken from the studio's customary repertory are perched on the step of the throne. The *Madonna and Child* among Cherubim and Seraphim in the Ford Collection in Detroit has greater force, owing to its intense and almost visionary plasticism. Dating from around 1460, the painting is particularly effective for its combination of sumptuous detail in the clothing, ornamented more in the manner of the goldsmith than of the painter (see the jeweled border of the Virgin's dress, painted on a slight relief of plaster), with the essential solidity of the brightly colored angels, sheltered by their numerous wings. The same design of the Madonna and Child was used for a far simpler, and badly damaged, painting in the Fogg Art Museum in

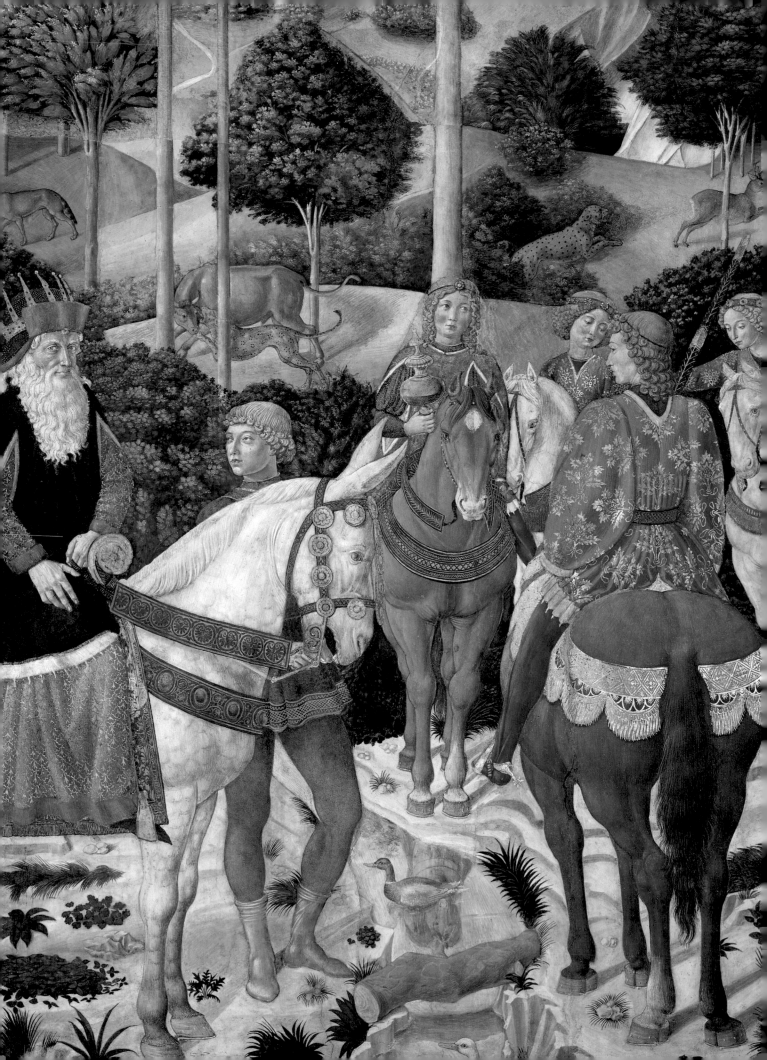

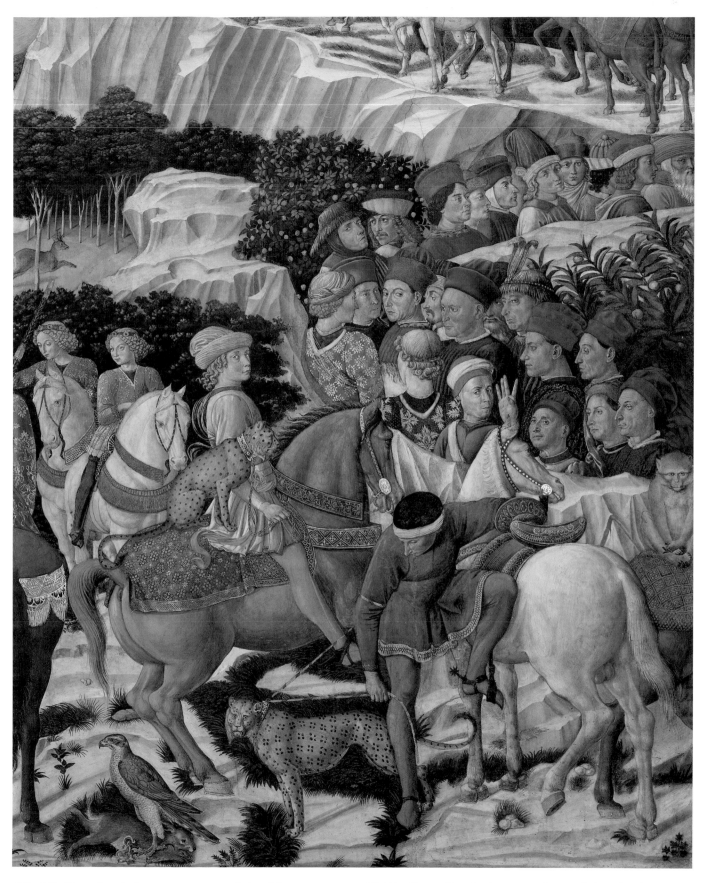

47, 48. *Details of the procession of the Magus Melchior*
Florence, Palazzo Medici Riccardi

49-51. *Saint Bartholomew, Saint John the Baptist, Saint James*
171x22.5 cm
Florence, Galleria dell'Accademia

52. Purification of the Virgin Mary
26x36 cm
Philadelphia, Museum of Art

53. The Dance of Salome
23.8x34.3 cm
Washington, National Gallery of Art

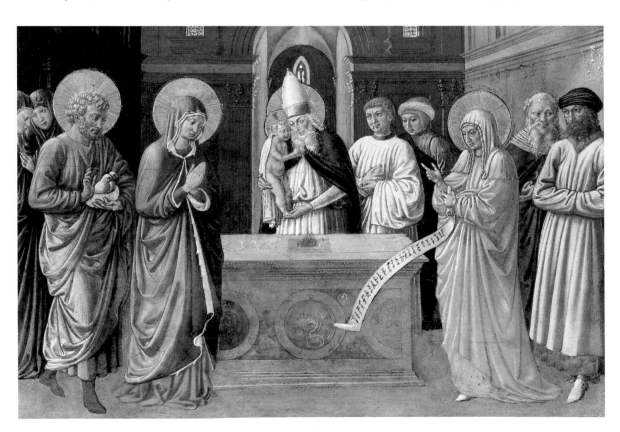

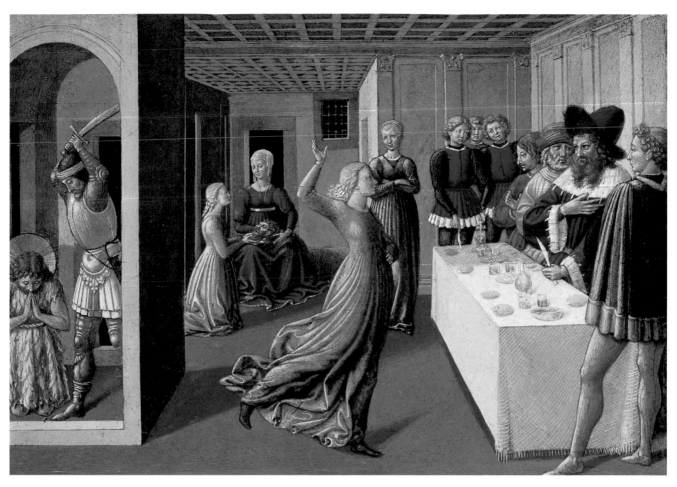

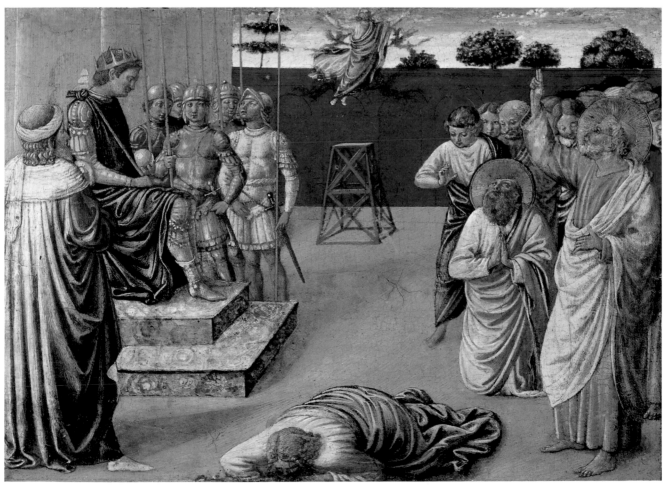

39

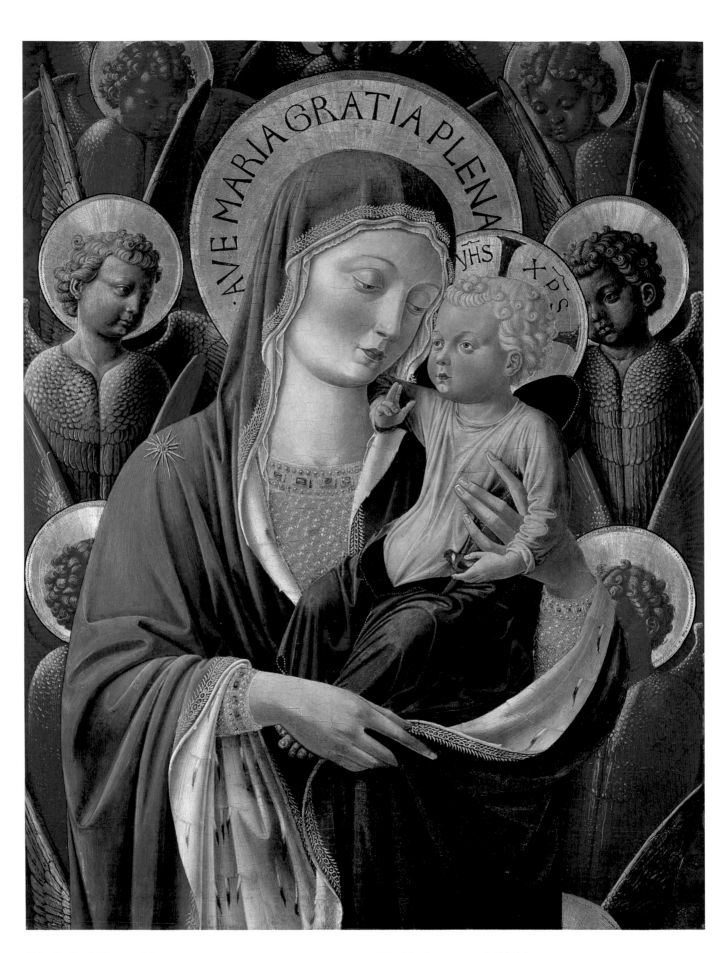

54. *Fall of Simon Magus*
24x35.5 cm
London, Hampton Court, Royal Collection

55. *Madonna and Child*
84.8x50.8 cm
Detroit, Institute of Arts

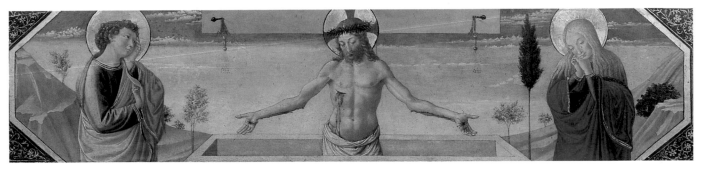

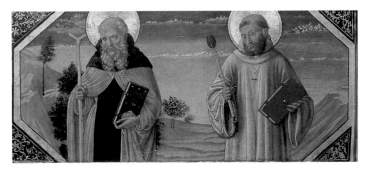

*56. Mystic Marriage of Saint Catherine; the Death of
Christ with Saint John the Evangelist and Mary
Magdalen; Saint Anthony Abbot and Saint Benedict
21x221 cm
Florence, Museo di San Marco*

Cambridge, Mass. Also from Benozzo's Florentine period date the finely painted panels of a predella from an unidentified altarpiece that were moved from Santa Croce to the Gallerie Fiorentine (and are now in the Museo di San Marco). In the same years he "updated" the altarpiece that the Alessandri had commissioned from Lippo di Benivieni for their chapel in San Pier Maggiore, adding a predella with five scenes, one of which has been lost. The remaining four are now in the Metropolitan Museum in New York: the *Fall of Simon Magus*, the *Conversion of Saint Paul on the Road to Damascus*, *Saint Zanobius raising a Child from the Dead*, and *Totila before Saint Benedict*. Small works in which the movements of the masses and the landscapes in the background are carefully studied, they not only show similarities with the scenes of the *Purification* but also reproduce some of the compositional motifs of the Chapel of the Magi, especially in the very pleasant landscape of the *Conversion*. Also assigned to his stay in Florence are a small picture of the *Crucifixion* among saints, of unknown location (formerly in the Drury-Lowe Collection at Locko Park), and, somewhat doubtfully, a delicate *Madonna dell'Umiltà* in a private collection in Munich.

In 1464 Benozzo, who had just married Lena di Luca di Jacopo Cieco, left Florence to fresco the choir of Sant'Agostino in San Gimignano. This was the first stage in a second and final series of journeys that took him to various places in Tuscany, without returning to the capital. He was accompanied by old and new collaborators: the faithful Giovanni d'Antonio della Cecca, Giusto d'Andrea who had joined the group without pay in order to improve his painting under Benozzo, and perhaps, according to Padoa Rizzo (1972, pp. 65-8), Lippi's pupil Pier Francesco Fiorentino. Thanks to the studies of Cole Ahl, the importance of the client has been recognized. He was the Augustinian Domenico Strambi, formerly a doctor at the Sorbonne and presumably the author of the iconographic program of the *Scenes from the Life of Saint Augustine* along with the relative inscriptions. Benozzo's stay in San Gimignano, which came to an end in 1467, was marked by demanding works, in locations of religious and civic prestige.

The Augustinian cycle consists of three rows of scenes set one above the other under the cross vault of the choir, decorated with the four Evangelists: the eighteen scenes (four of them in the lunettes) cover the whole of St Augustine's life, from childhood to death. A frame of painted pilasters with putti in mock relief amidst foliage unifies the sequence of rectangular panels in a captivating classical style. In the central scene depicting *Saint Augustine leaving Rome*, under the single-light window, the commemorative inscription of the cycle is given suitable emphasis, held up by two flying angels in the pose of ancient winged Victories: "ELOQVII SACRI DOCTOR PARISINVS ET INGENS / GEMIGNANIACI FAMA DECVSQVE SOLI / HOC PROPRIO SVMPTV DOMINICVS ILLE SACELLVM / INSIGNEM IVSSIT PINGERE BENOTIVM", followed by the date MCCCCLXV, 1465, linking in celebration the "Parisian doctor" and the "illustrious" painter. While for the scenes from St Francis's life in Montefalco Benozzo had been able to draw on a well-established iconographic tradition, a cornerstone of which, the Basilica in Assisi, was well known to him, he was unable to rely on significant precedents for the extensive cycle of the life of St Augustine. Here he found himself having to translate into images episodes that were undoubtedly related and glossed by the learned client, Fra Domenico Strambi. Benozzo responded to this challenge with a firm and resolute style of painting, based on a rational clarity that makes it particularly intelligible and in which the integration of the full and majestic figures with the urban or rural setting achieves a harmonious equilibrium. Whether divided in two or unified by an axial perspective, the solemn urban scenes contribute greatly to the stately character of the cycle, filled as they are with learned inventions and architectural citations. The baptismal font on fluted Corinthian pillars in the *Baptism of Saint Augustine*, the great monastery reminiscent of Brunelleschi's Spedale degli Innocenti in the *Funeral of Saint Augustine*, the "ideal" Milanese square of the *Scenes with Saint Ambrose*, with its paving decorated with an intellectualistic two-color pattern, and other backdrops constitute views of great evocative power, true elements of mediation between the Brancacci Chapel and the cycles of Ghirlandaio, "establishing a dialogue with both Filippo Lippi's cycle in Prato and Piero della Francesca's in Arezzo" (Padoa Rizzo 1992, p. 15). Yet there are also playful touches of everyday life, such as the depiction of a school of grammar, whose severity is represented by the corporal punishment of a reluctant pupil. Standing out among the figures, which are mainly generic typifications, are numerous portraits. This was a practice that Benozzo had tried out extensively in the Medicean Chapel of the Magi and never subsequently abandoned. The face of the client Strambi may be portrayed in the monk on the right holding the clothes of the neophyte in the *Baptism* (Ronen 1988). But it is in the scenes of *Saint Augustine departing for Milan* and *Saint Augustine teaching in Rome*, which are among the most visible owing to their location on the bottom row, that we can guess at the presence of other prominent figures in the city's civil and religious life, including a political personality (the man in a red cloak welcoming Augustine in the *Disembarkation at Ostia*) whose face was damaged at a later date.

The painters too put in an appearance, both as full figures and as heads alone: there is Benozzo, finely dressed in pink cloth, and his group of assistants, including the young man already portrayed in the Chapel of the Magi, and whom I believe to be Giovanni di Mugello, and a young man with curly auburn hair whom Vasari erroneously took as a model for the engraving that accompanies his *Life* of Gozzoli. Beneath the skies of cold ultramarine the festive clarity of the colors (which is not even diminished by the black tunics of the Augustinians, owing to their reflections) is reminiscent of the precious and varied style of the Chapel of the Magi; but the orchestration of complex spatial divisions through a sounder grasp of perspective reveals an indisputable improvement in Benozzo's technique.

Along with the original commission, Benozzo received a number of unexpected requests, including two *Pestbilder*. The arrival of the plague in San Gimignano in the spring of 1464 revived devotion to St Sebastian, who was believed to offer protection against the dreaded scourge. So the Augustinian community, perhaps at the behest of Strambi itself, agreed with the Compagnia di San Sebastiano to have Benozzo execute a wall painting of *Saint Sebastian Intercessor* above the Pesciolini altar in Sant'Agostino. This appears to have been a commemoration of the end of the epidemic in July of that year. The painting, whose delicacy and skill of execution, with lapis-lazuli and white lead applied *a secco*, has been revealed by the restoration (Rossi 1991), has recently attracted the attention of critics for the innovative complexity of its iconography (Ronen 1988, Cole Ahl 1988). The saint, clothed instead of naked and pierced with arrows as in the more usual representations, stands on a pedestal surrounded by devotees of all kinds and

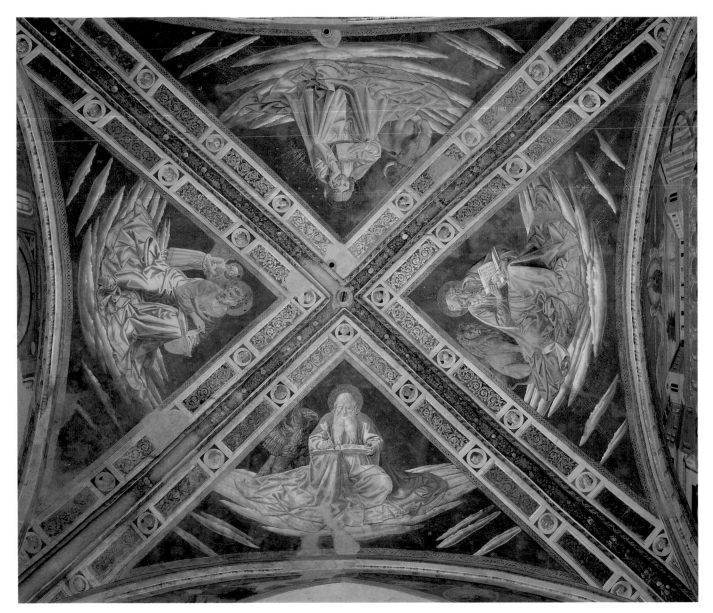

57. Vault representing the Evangelists
San Gimignano, Sant'Agostino

ages; in the upper level, with ancient gestures of intercession, the Madonna shows her breasts and Christ his wounds to the Eternal Father, enraged and bent on hurling pestilential arrows with the assistance of hosts of angels. Below two pairs of angels are trying to break the arrows. The Augustinian behind the white-haired man in profile on the left is probably a portrait of Strambi.

As far back as January 4, 1463 (1462 Florentine style) the city government had decided to have an image of St Sebastian painted in the chapel dedicated to him in the old parish church, the Collegiata. It now took the opportunity of the presence of a "distinguished" painter from Florence to entrust him with the task of painting this second *Pestbild* in February 1465 (1464 Florentine style), even though the epidemic had been over for seven months. Benozzo signed the mural in the collegiate church on January 18, 1466 (1465 Florentine style) as part of a long inscription

in capital letters dedicated to the saint: "AD LAUDEM GLORIOSISSIMI ATHLET[A]E SANCTI SEBASTIANI HOC OPVS CONSTRVCTVM FVIT DIE XVIII. JANVARII. M.CCCC.LXV. BENOZIVS FLORENTINVS PINXIT." This time the saint is naked and shot with arrows, as in the usual iconography, and much of the painting was executed by assistants (see the mannered *condottiere* in the foreground, almost certainly by Giovanni di Mugello). Above, within a radiant mandorla crowded with cherubim, seraphim, and other multicolored angelic figures, the praying Virgin Mary appears to be beseeching her Son to accept the martyr's soul. The pleasant character of the landscape in the background and the conscientious care taken over detail in the figures are not sufficient to redeem the predictable pictorial representation and static composition. A number of other works, on board or wall and executed with a greater or lesser contribution from the assistants, also date from the San Gimignano period. In the city's Museo Civico there is a picture with an almost square predella depicting the *Madonna and Child with Saints Andrew and Prosper*, which Benozzo finished painting in August 1466 for the high altar

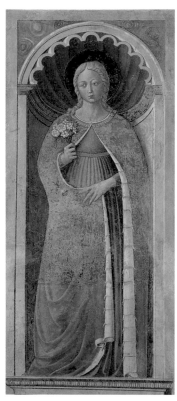 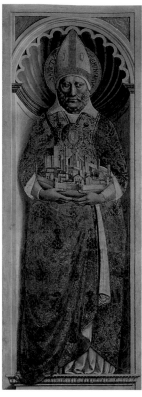

58-60. *Saint Fina, Saint Gimignano, Tobias, and the Angel*
San Gimignano, Sant'Agostino

61, 62. *The School of Tagaste*
San Gimignano, Sant'Agostino

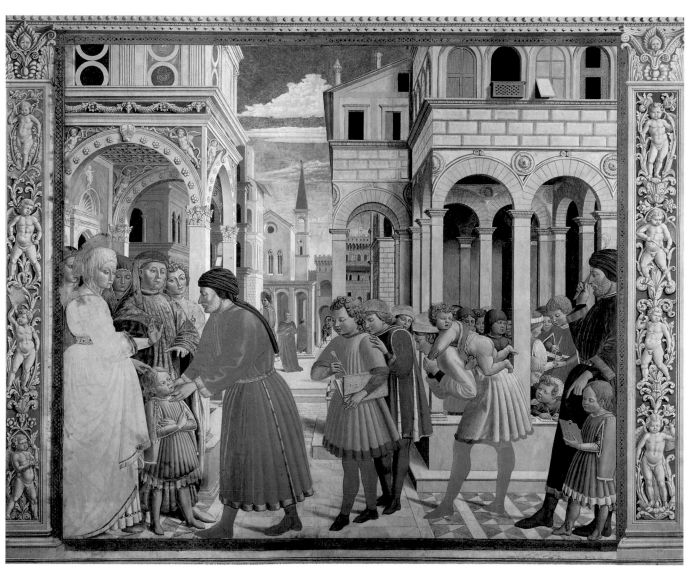

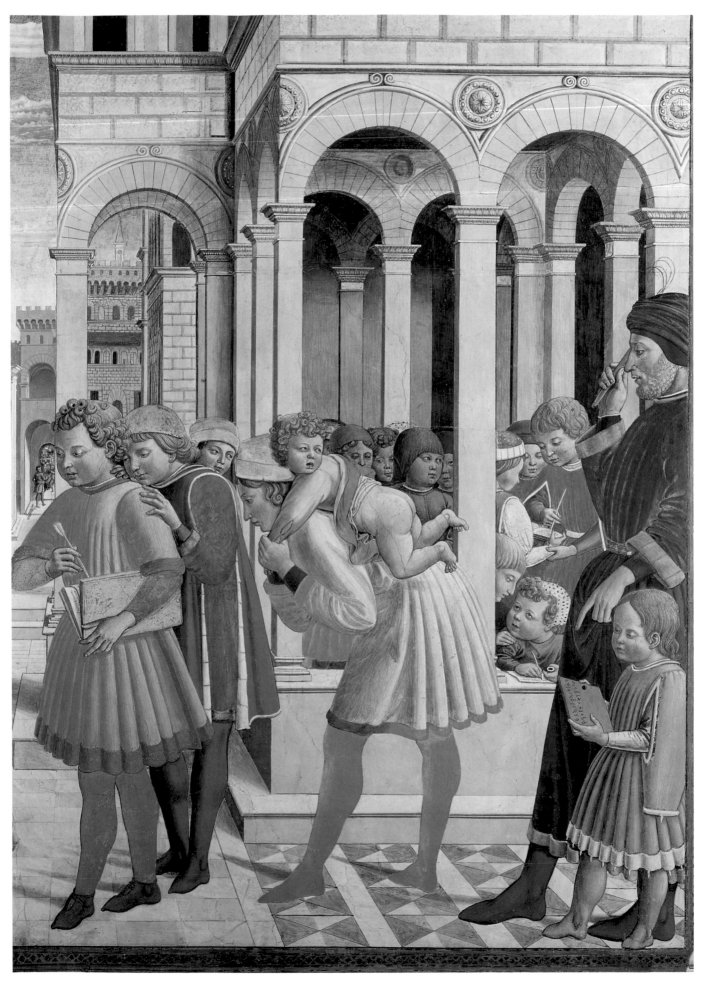

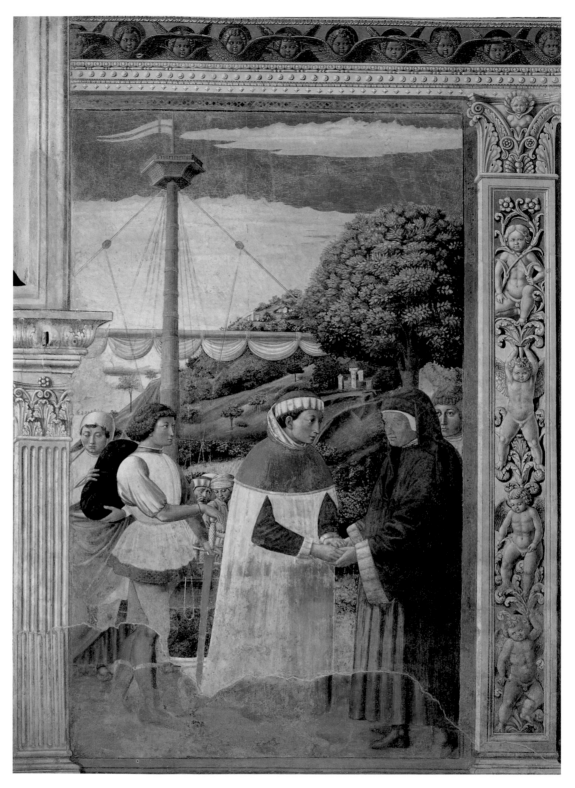

63. *Saint Augustine disembarking at Ostia*
San Gimignano, Sant'Agostino

64. *Saint Augustine teaching in Rome*
San Gimignano, Sant'Agostino

65. *Saint Augustine leaving Rome*
San Gimignano, Sant'Agostino

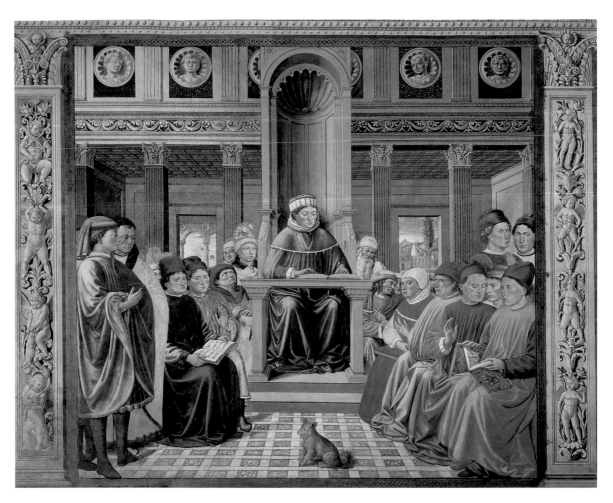

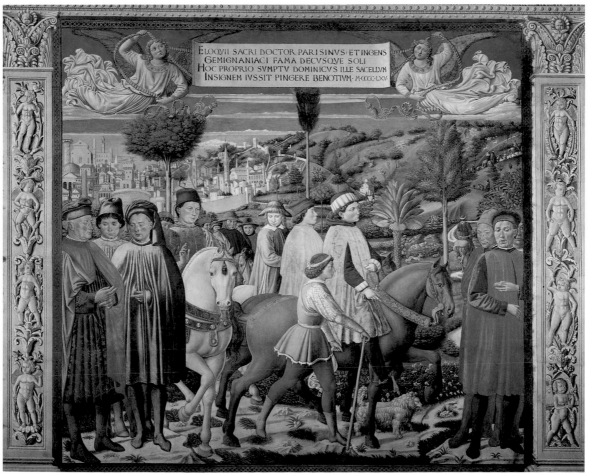

ELOQVII SACRI DOCTOR PARISINVS/ET INGENS
GEMIGNANIACI FAMA DECVSQVE SOLI
HOC PROPRIO SVMPTV DOMINICVS ILLE SACELLVM
INSIGNEM IVSSIT PINGERE BENOTIVM · M·CCCC·LXV·

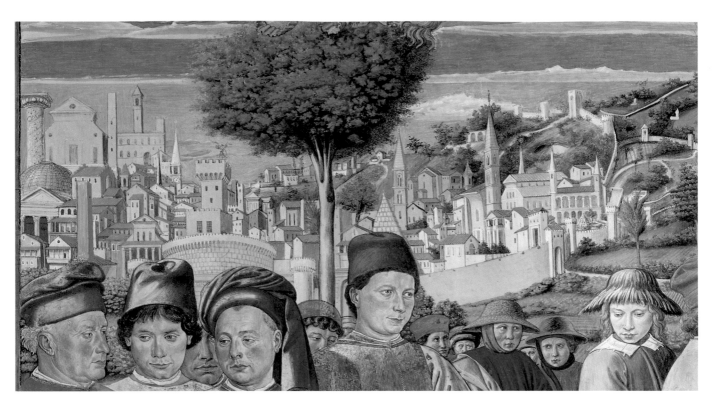

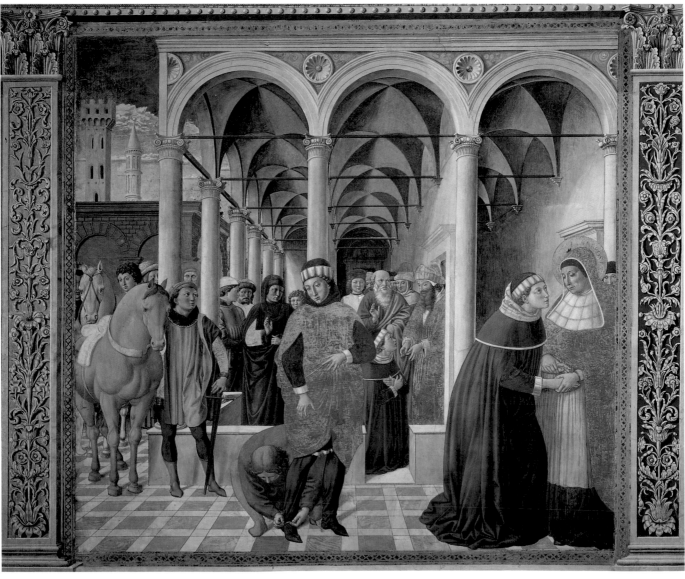

48

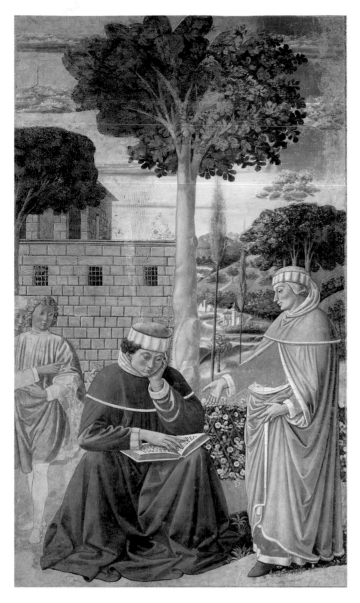

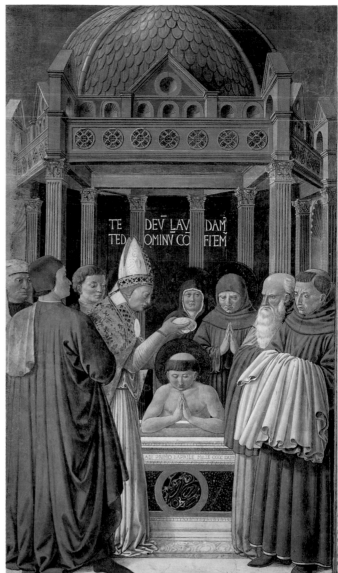

66. *Saint Augustine leaving Rome, detail*
San Gimignano, Sant'Agostino

67. *Arrival of Saint Augustine in Milan*
San Gimignano, Sant'Agostino

68. *Saint Augustine reading the Epistle of Saint Paul*
San Gimignano, Sant'Agostino

69. *Baptism of Saint Augustine*
San Gimignano, Sant'Agostino

70. *Visit to the Monks of Mount Pisano*
San Gimignano, Sant'Agostino

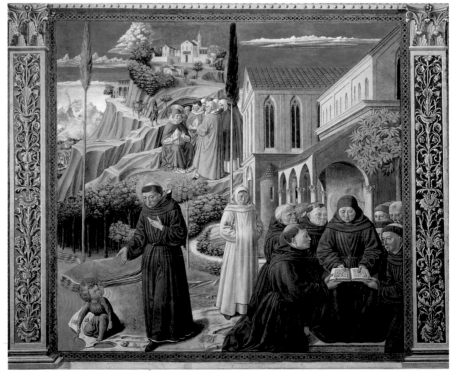

49

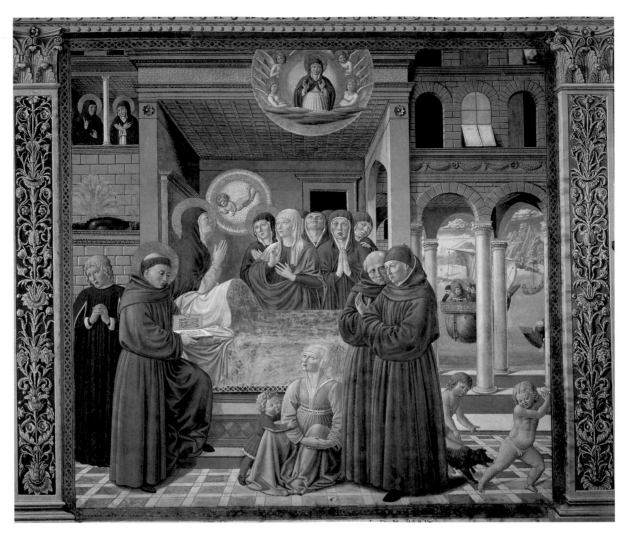

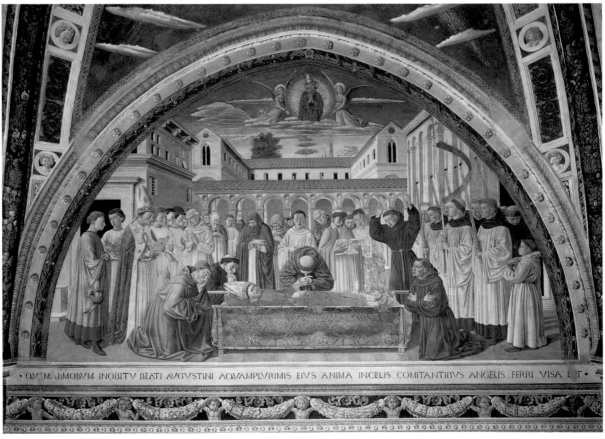

· QVEM·ABMODVM·INOBITV·BEATI·AVGVSTINI·AQVAMPLVRIMIS·EIVS·ANIMA·INCELIS·COMITANTIBVS·ANGELIS·FERRI·VISA·E·T·

71, 73. *Death of Saint Monica*
San Gimignano, Sant'Agostino

72. *Funeral of Saint Augustine*
San Gimignano, Sant'Agostino

74. *Saint Sebastian Intercessor*
527x248 cm
San Gimignano, Sant'Agostino

75. *Martyrdom of Saint
Sebastian*
525x378 cm
*San Gimignano, Collegiate
church*

76. *Madonna and Child between
Saints Andrew and Prosper,
detail*
137x138 cm
San Gimignano, Museo Civico

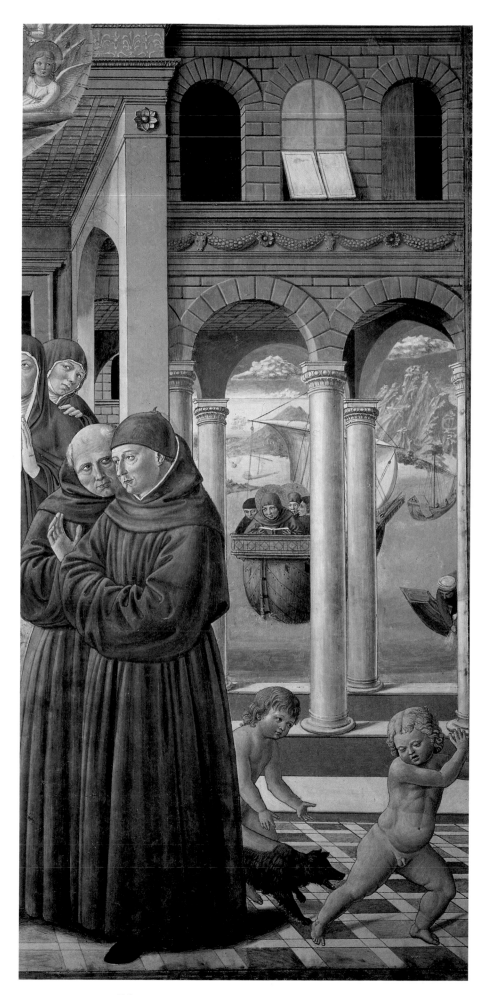

51

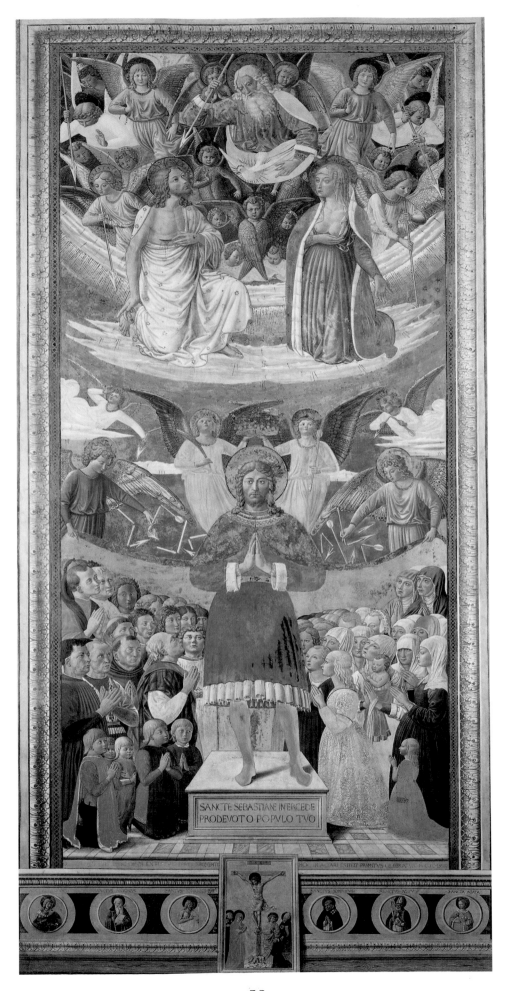

SANCTE SEBASTIANE INTERCEDE
PRODEVOTO POPVLO TVO

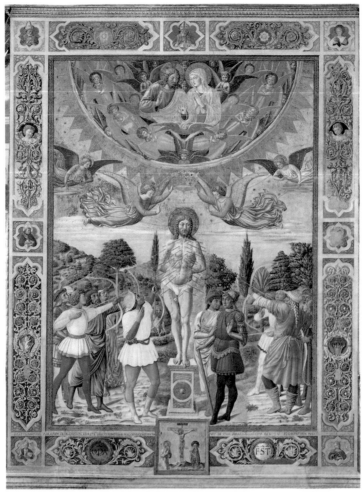

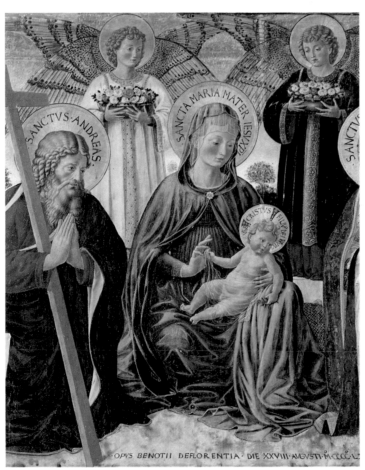

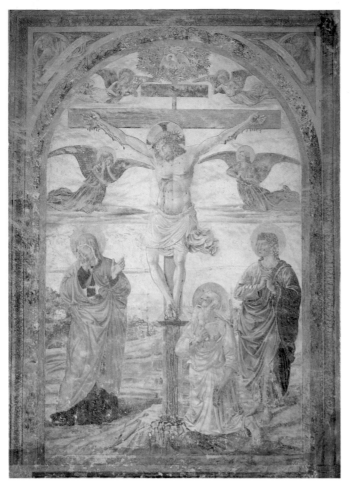

77. *Crucifixion with Mourners and Saint Jerome*
350x220 cm
San Gimignano, Convent of Monteoliveto Minore

78. *Saint John the Evangelist (?)*
21x22 cm
Bergamo, Accademia Carrara

of the church of Sant'Andrea, on commission from the priest Girolamo di Niccolò. Rather than the main scene, accurate but lacking in vitality, it is the predella with *Christ in the Tomb among Mourners and Saints*, with its small figures set against a soothing and unifying landscape, that remains in the memory. The Museo Civico also contains a picture of the *Madonna Enthroned among Saints John the Baptist, Mary Magdalen, Augustine, and Martha* (1466), originally in the monastery of Santa Maria Maddalena. In it great attention was given, around the solid volumes of bodies shaped by the light, to ornaments of the most varied kind: silk hangings, festoons of alternating red and white roses, jewelry, and mottled marbles, not to mention the customary gilded haloes with elegant explanatory inscriptions. A predella in San Gimignano was also the source of the fragments now divided among the Petit Palais in Avignon, with Saints Fina and Mary Magdalen; the Thyssen Collection, with St Jerome and a monk with a burst of rays instead of a circular halo (the Blessed Bartolo Buompedoni according to Bartalini, 1990, but the features are the same as those of the presumed portrait of Strambi); and finally the Pinacoteca di Brera in Milan, with the *Dead Christ and Mourners*.

An appreciation of Benozzo's mural paintings in San Gimignano is hampered by their poor state of preservation. They are the *Crucifixion with Mourners and Saint Jerome* (1466) in the Benedictine convent of Monteoliveto Minore, which was mentioned by Vasari, and the *Crucifixion with Saint Jerome, Saint Francis, and the Donor*, originally in the Palazzo Pubblico but detached in the last century and transferred to the Museo Civico. Between 1466 and 1467 Benozzo was engaged on a work of little quantitative significance but great symbolic importance in that same City Hall. As a clear sign of the trust that was placed in the "distinguished" painter, whose reputation had been established by the recent Medicean chapel, he was asked to "restore" the *Maestà* of Lippo Memmi. This he did by redintegrating the figures at the edges and the damaged inscriptions, and retouching the whole composition.

While working on the most important buildings in San Gimignano, Benozzo did not fail to accept other commissions, for which he often supplied no more than the drawings, leaving most of the painting itself to his group of assistants. In 1466 he approved, appending his signature and date, a cuspidate panel depicting the *Mystic Marriage of Saint Catherine* with Saints Bartholomew, Francis, and Lucy for the church of Santa Maria dell'Oro near Terni, now in the Museo Civico of that city (Padoa Rizzo 1972, pp. 135-6). It has an old-fashioned type of composition and was executed with great care.

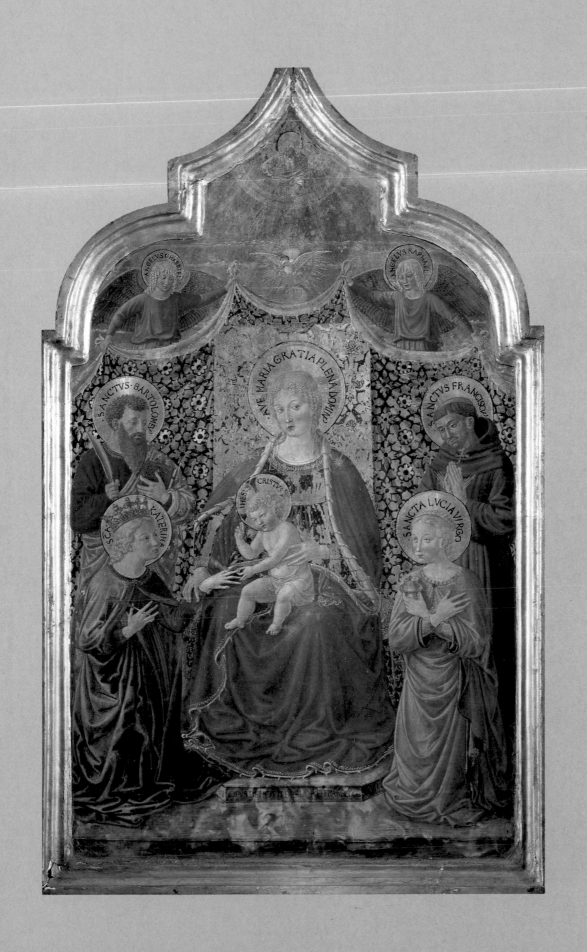

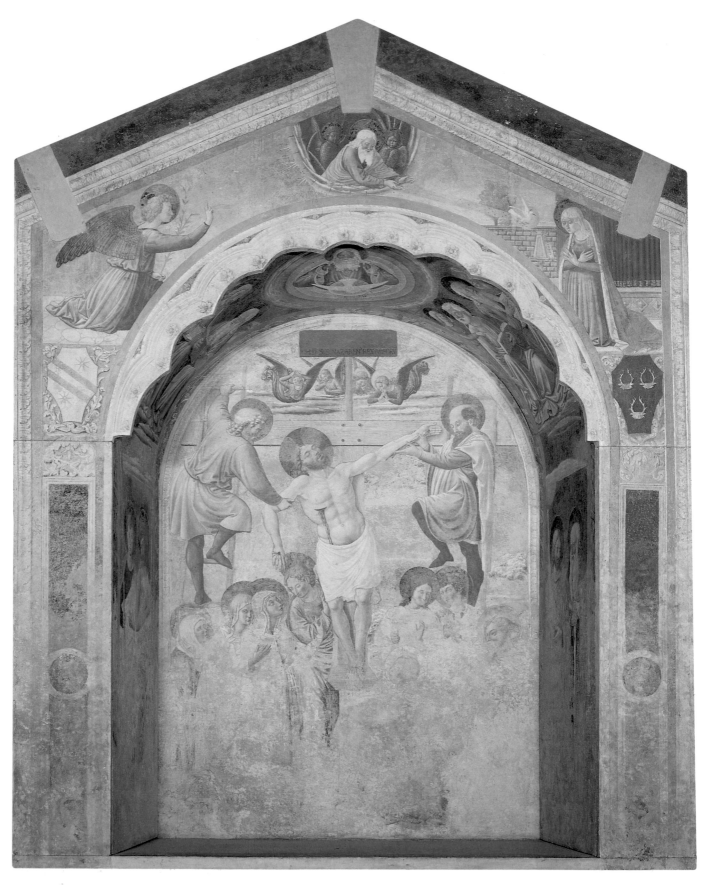

79. *Mystic Marriage of Saint Catherine and Saints*
90x50 cm
Terni, Pinacoteca Civica

80. *Shrine of the Executed*
Certaldo

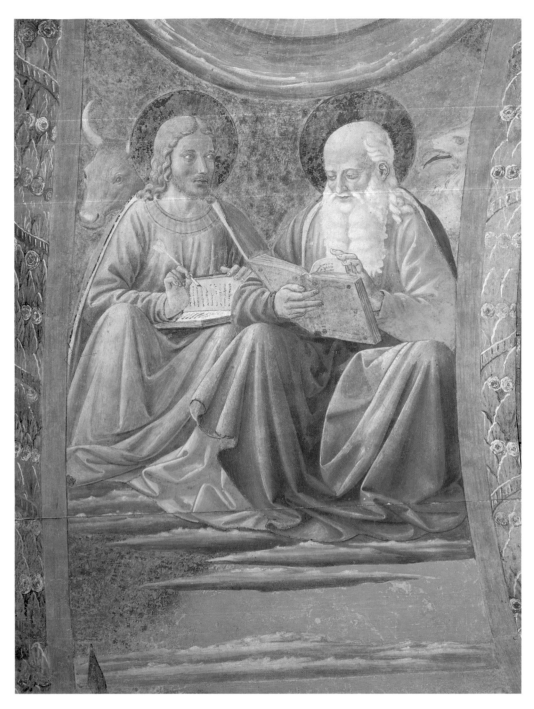

81. Shrine of the
Executed
detail of the Evangelists
Luke and John
Certaldo

In 1464-5, at exactly the same time as he was working on the frescoes in the choir of Sant'Agostino, he had painted the interior and exterior of the *Shrine of the Executed*, a small temple that originally stood on the banks of the river Agliena, along the route taken by those condemned to death. After detachment in 1957, the frescoes and *sinopie* are now located in the church near the Palazzo dei Vicari. The complex set of images, hinging, for the consolation of the condemned, on the sufferings of Christ and the protection of the saints, includes: the *Annunciation* on the front arch, the *Eternal and the Holy Spirit among the Evangelists* on the small barrel vault, *Saints Longinus, John the Baptist, James, and Anthony Abbot* on the walls, the *Descent from the Cross* on the rear wall, and the *Crucifixion*, *Resurrection*, and *Martyrdom of Saint Sebastian* on the outside. Only the first two of these frescoes, in the arch and on the vault, have preserved the paint to any great extent, while on the remaining parts it has almost vanished due to the long exposure to atmospheric agents and humidity. The figures are set against a dense blue sky (in those parts where the color has not altered) with an extremely immobile monumentality, except for Longinus and Joseph of Arimathea who, supporting the body of Christ, maintain an elegant equilibrium on both scales. The colors, artfully distributed in accordance with a principle of *varietas* in the alternation of primaries and secondaries, have at times the clarity of Piero della Francesca in their highlights, but the dense red tone of the wings, hose, tablet, and drape have the feeling of the fabulous sumptuosity of the Magi cycle. Much of the execution of the shrine's decoration was entrusted to assistants, including Giusto d'Andrea.

Approaching the age of fifty and with a reputation that had spread throughout Tuscany and Umbria, Benozzo was called on to undertake one of the most grandiose labors that a painter in Central Italy could aspire to in those days: the completion of the frescoes in the Camposanto of Pisa, left unfinished the previous century. On January 1, 1469 (1468 Florentine style), the Operai della Primaziale, as the board of trustees was known, officially entrusted him with the task of painting the long north wall, and he had concluded the work before May 1, 1484, the date of the last payment. Thus over a period of fifteen years he brought to completion an enterprise, at the head of his studio, that "would have rightly scared a legion of painters." There is reason to believe that the bishop of Pisa, Filippo de' Medici, very active in the field of artistic patronage as was the family's custom, may have played a part in the selection of Benozzo; and, though it may be no more than mere coincidence, it is worth mentioning the fact that the day the contract was drawn up was also Lorenzo de' Medici's twentieth birthday. In 1944 a bombing raid, followed by a disastrous fire, destroyed or damaged the greater part of the frescoes. In spite of the restoration carried out after the war, they have remained disfigured and, as they are kept in storage, not on view. Nor can the sight of the *sinopie* in Pisa's Museo delle Sinopie, made possible by their detachment, do justice to what was the masterpiece, or at least the most demanding work, of Benozzo's whole career. At the time when the Florentine artists of a later generation — Botticelli, Cosimo Rosselli, Ghirlandaio — began to try their hand at the monumental dimension of the walls of the Chapel of Sixtus IV in Rome, in 1482, Benozzo was completing a pictorial undertaking of equal compositional complexity, and one which some of them, especially Rosselli and Ghirlandaio, kept in mind for their works in Rome.

In the Camposanto Gozzoli, with the assistance of the brothers Bernardo and Giovanni and of Fra Angelico's nephew, depicted the *Annunciation* and the *Adoration of the Magi, Apostles, and Saints*, but most of his efforts went into the series of twenty-three scenes from the Old Testament: *The Vintage and Drunkenness of Noah, The Cursing of Ham, The Tower of Babel, Abram and the Worshippers of Belo, Departure of Abram and Lot, The Victory of Abram, Stories of Hagar, The Burning of Sodom, Stories of Isaac, The Wedding of Isaac and Rachel, Stories of Esau and Jacob, Dream and Wedding of Jacob, Meeting of Jacob and Esau with the Ravishing of Dinah, Joseph's Innocence, Joseph at the Court of the Pharaoh, Moses's Youth, The Crossing of the Red Sea, Moses and the Tables of the Law, The Story of Korah, Dathan, and Abiram, Aaron's Rod and the Serpent of Bronze, The Death of Aaron and Moses, The Fall of Jericho and David and Goliath,* and *The Meeting of Solomon and the Queen of Sheba.*

By describing it as an *opera terribilissima*, Vasari honored Benozzo's work with the adjective that he chiefly, though not exclusively, used in his *Lives* for the in-superable art of Michelangelo. And even though he was referring to the scale and importance of the undertaking rather than to the dazzling grandeur of the results (as with Buonarroti), the term is still an expression of the admiration that the not very indulgent biographer, and to an even greater extent Benozzo's contemporaries, had for his most demanding work. As far as can be judged from the black and white photographs of the frescoes taken before 1944 and recent pictures of the damaged remains, in his planning of the large scenes Gozzoli made use of all the experience and knowledge he had acquired, commencing with his formative apprenticeship with Ghiberti. Traces of Ghiberti's mechanisms of composition, so skillfully contrived that several episodes are able to coexist in the same panel with elegant naturalness, can still be recognized even after so many years. In the large scenes we find the tidy and pleasant landscapes that, painted for the first time on the scale of the fresco in Montefalco, had exquisitely decorated the walls of the Chapel of the Magi. At the same time there is the exact and richly detailed architecture that had framed the *Scenes from the Life of Saint Augustine* in San Gimignano, here however enhanced by the breadth of the perspective (worthy of Paolo Uccello in the *Stories of Noah*, with the vertiginous convergence of the pergola and the porticoed building) and magnified even further in the urban groupings (see the city in the *Tower of Babel*, filled with the transfigured monuments of Rome and Florence). Observing the rigor of the "ideal city" that can be detected in the architectural backdrops of the Pisan cycle, Padoa Rizzo has rightly pointed out that Gozzoli "in this way makes himself a protagonist of the debate over this subject, more Humanistic than any other, alongside the theorizations of Alberti or Filarete and the few practical realizations (Pienza, Urbino) and the visualizations provided by means of inlaid work or painted 'perspective scenes'" (1992, pp. 17-18). Equally remarkable is the organization of the figures in groups into genuine masses: in the latter portraits abound, in accordance with a now established custom in Florentine painting although one of which Benozzo had been a forerunner in the Chapel of the Magi many years earlier (Acidini Luchinat 1993). The extraordinary accuracy of the guiding drawings, as revealed by the *sinopie*, provides an even better testimony than the ruined paintings themselves to the scrupulous professionalism with which, as was his wont, Benozzo approached this work, following the precepts of traditional *buon fresco* and probably (though we have no technical proof of this) enriching his means of expression by the use of precious pigments applied *a secco*.

Although exacting and long, the work in the Camposanto did not prevent Benozzo from accepting other commissions over the period of these fifteen years, and others were to follow in the remaining time that he spent in Pisa, which was abruptly interrupted in 1494 when, with the expulsion of Piero di Lorenzo de' Medici, Pisa rediscovered its ancient enmity with Florence and drove out the Florentines who lived within

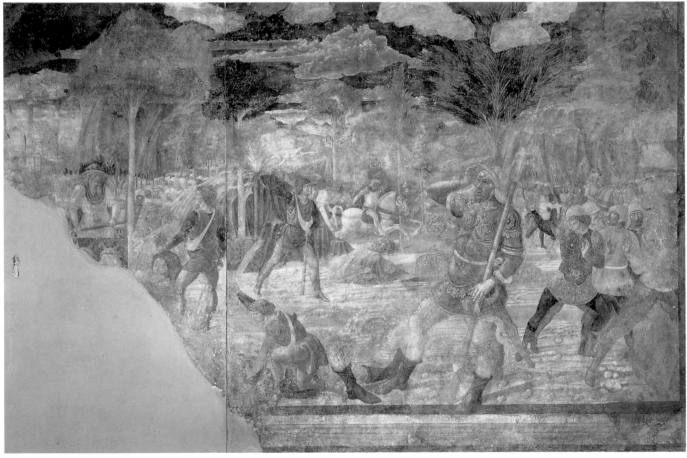

82. *The Vintage and Drunkenness of Noah*
Pisa, Camposanto

83. *David and Goliath*
Pisa, Camposanto

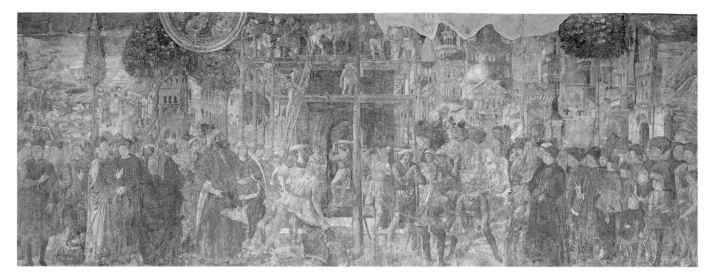

its walls. One large painting on board of his that, re-moved during the Napoleonic period, is now in the Louvre, had a particularly important location: to use Vasari's expression, "behind the Archbishop's seat" in Pisa Cathedral. The shaped and arched panel depicts Christ in the act of approving the writings of St Thomas of Aquinas (in fact the phrase BENE SCRIPSISTI DE ME THOMMA can be read), while the saint is seated in the middle, between Plato and Aristotle, and has at his feet a defeated Oriental sage, presumably a schismatic, as a sign that the Thomist philosophy, heir and continuation of ancient schools of thought, represented a powerful bulwark of religious orthodoxy. In the row underneath, in a crowded scene that the painter has arranged with skillful originality

84. *The Building of the Tower of Babel*
Pisa, Camposanto

85, 86. *"Sinopie" of the Annunciation*
Pisa, Museo delle sinopie

60

around an empty space, there are, to quote Vasari, "an infinite number of learned men, debating his works, and among them is portrayed Pope Sixtus IV with a number of Cardinals, and many heads and generals of various orders." Once again it is to Vasari that we owe the assessment of the carefully executed work as "the most finished and best that Benozzo ever did." The mention of Sixtus IV allows us to date the picture to the years following his election, in 1471.

In describing Benozzo's activity during the long period he spent in Pisa, it is necessary to bear in mind the increasingly important role played by his collaborators, who in the nineties were joined by his sons Francesco and Alesso. The latter can be identified with the painter of a group of pictures that are conventionally attributed to the "Scanty Master" ("Maestro Esiguo") or "Pupil of Benozzo". One of the paintings that were composed by the master on the basis of now proven schemes and completed by his assistants was undoubtedly the *Madonna and Child with Saints Rock, Lawrence, Anthony Abbot, and Bernardine of Siena* in the Museo dell'Opera of Pisa Cathedral. Originally in the church of San Lazzaro, it was painted in 1470 on a commission from Gian Piero da Porto Venere and Michela "della Spezie" (La Spezia), who are portrayed on a small scale, kneeling at the foot of the throne. Of only slightly better quality is the picture of the *Madonna and Child with Saints John the Baptist, Gregory, Dominic, John the Evangelist, Julian, and Francis*, which Vasari mentions as having been painted for the Compagnia dei Fiorentini, the confraternity of Florentines resident in Pisa (now in the National Gallery of Canada, in Ottawa): commissioned by the influential Lotto di Giovanni di Forese Salviati at a date that does not seem to be the 1473 in the inscription, which may have been altered by an erroneous rewriting in the past (Hurtubise 1981-2, Padoa Rizzo 1992), but 1477 or 1478, that is to say close to the time when Salviati was captain of Pisa (1476-7), the altarpiece has a layout that had been used on many occasions but that retains its effectiveness owing to the smooth circular arrangement of figures in space. There are elements of remarkable intensity in the gazes of the hieratic St Gregory and the elegant St Julian, directed toward the observer. Again for a private client, the Pisan citizen Pietro di Battista d'Arrigo di Minore, in 1481 Benozzo painted a *Pestbild* or votive picture celebrating the avoidance of the danger of plague. Having passed into a collection in Paris, this was acquired in 1971 by the Metropolitan Museum in New York. It portrays the "defenders" *Saints Nicholas of Tolentino, Rock, Sebastian, and Bernardine of Siena*, whose authoritative presence wards off the impending pestilential arrows wielded by angels, here in the guise of executors of divine wrath, from the territory of Pisa and the small kneeling figures of the clients.

The ecclesiastical buildings of Pisa contain, diminished by time and decay, other examples of Gozzoli's art, though none of them can compete with the level of quality achieved at the same time in the Camposanto. Evidence for his continuing ties with the Dominican

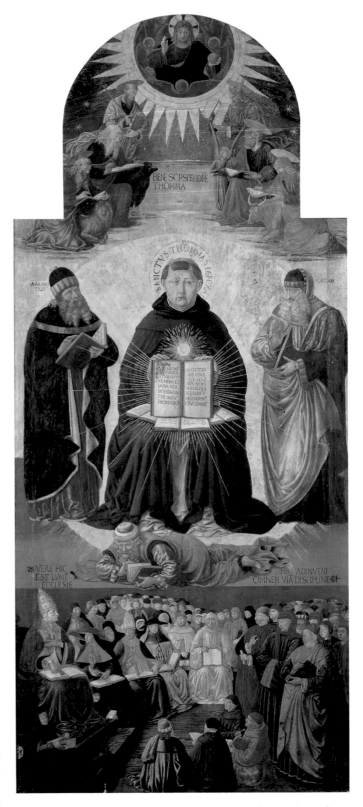

87. *Triumph of Saint Thomas Aquinas*
230x102 cm
Paris, Louvre

61

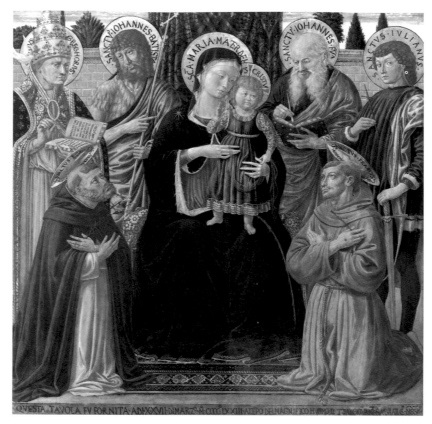

QVESTA TAVOLA FV FORNITA ADI XXVII DI MAR 7º M·CCCC·LXIII A TÉPO DEL MAGNIFICO HV[...]

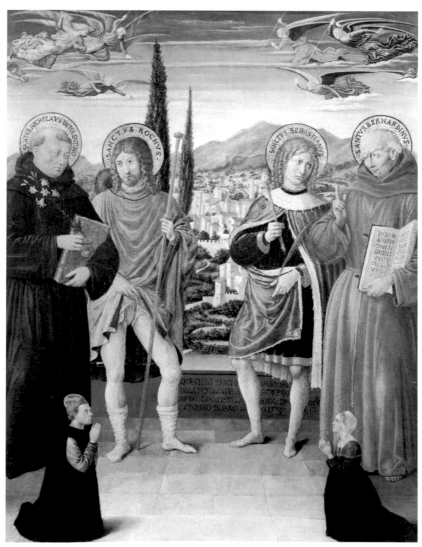

88. *Madonna and Child with Saints John the Baptist, Gregory, Dominic, John the Evangelist, Julian, and Francis*
153x155 cm
Ottawa, National Gallery of Art

89. *Saints Nicholas of Tolentino, Rock, Sebastian, and Bernardine of Siena*
78.7x61.9 cm
New York, Metropolitan Museum of Art

90. *Madonna and Child Enthroned among Saints Benedict, Scholastica, Ursula, and John Gualberto*
153x133 cm
Pisa, Museo Nazionale di San Matteo

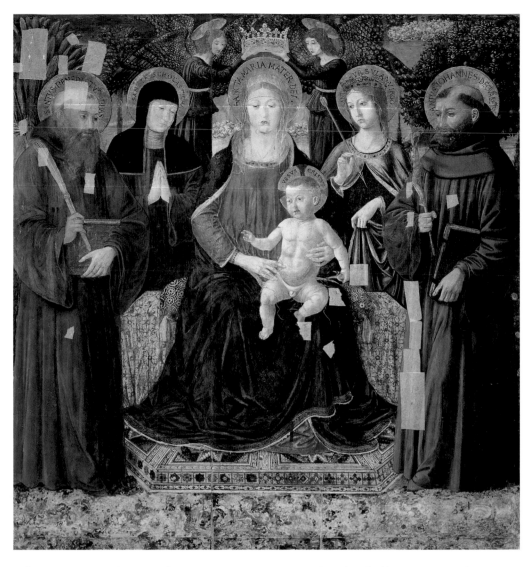

order is provided by the mural paintings in the nuns' refectory of San Domenico, mentioned by Vasari. All that remains today is a *Crucifixion* with the Virgin Mary, John, Mary Magdalen, and Martha, along with kneeling saints of the Dominican order: Catherine of Siena, Dominic, Peter the Martyr, Thomas of Aquinas, and Vincent Ferrer, with four nuns. Full of gaps, damaged by flood waters from the river Arno, and altered by the nineteenth-century restoration, the great composition maintains its bipartite character, with the upper section enlivened by the convulsive flight of the angels gathering up the blood of Christ, and the lower one taken up by two rows of kneeling figures, whose distribution of masses is articulated by the alternation of the order's colors, white and black, in the tunics and cloaks.

There is very little left of another important decorative work by Benozzo in a Pisan nunnery, that of San Benedetto at Ripa d'Arno, where according to Vasari he painted the *Scenes from the Life* of the patron saint. A mural painted in fresco depicting the cross surrounded by angels and, at the sides, the Virgin Mary and St John was found in a niche of the convent's church, and restored prior to 1972. The painting, of great artistic quality and expressive force, was evidently accompanied by an image, probably a statue, representing the dead Christ. From the same convent comes the picture in the Museo Nazionale di San Matteo depicting the *Madonna Enthroned* among Saints Benedict, Scholastica, Ursula, and John Gualberto, personages particularly suited to a community of Vallombrosian nuns. The reduction, not common in Benozzo's work, of the range of colors to a few highly contrasting tints — bright red, the pale blue of the sky, gold, and the dark shades of the cloaks and habits — appears to lend the painting an indefinable fascination, almost an air of melancholy. However it will be necessary to wait for its restoration, which may bring to light colors closer to those of the original, before making a final judgment. The figures of Saint Ursula and the angels appear to be the work of another painter, and the name of Benozzo's son Francesco has been put forward (Padoa Rizzo 1992, p. 126). I would associate this painting with the *Saint Ursula* in Washington, though more for stylistic affinities than for similarities of iconography.

From the monastery of Santa Marta, finally, came the picture now in the Museo di San Matteo, with its charming painted frame in the shape of a shrine, depicting *Sant'Anna Metterza* and female donors. Restoration has confirmed that it is largely Benozzo's own work, along with the date of around 1468-70

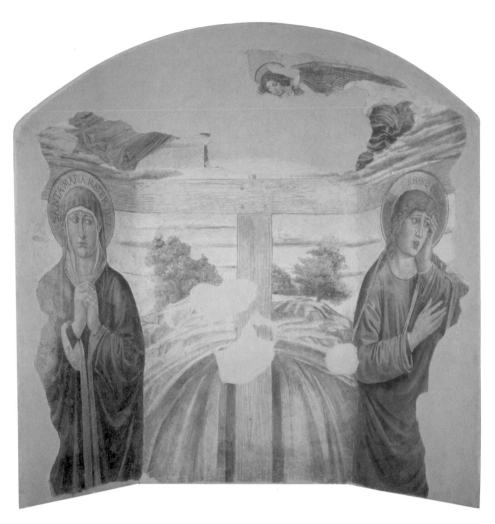

91. *The Virgin Mary, Saint John the Evangelist, and Two Angels at the Sides of the Cross*
Pisa, San Benedetto a Ripa d'Arno

92. *Madonna and Child*
75x45 cm
Calci, Parish church

(M.G. Burresi 1992). Further evidence of Benozzo's activity in the territory of Pisa is provided by the arched panel depicting the *Madonna and Child* in the parish church of Calci, originally in the nearby convent of the Dominicans on the Poggio: a picture as archaic and hieratic as a Byzantine icon (perhaps painted, if the hypothesis is not too rash, to replace an old and venerated image that had deteriorated), it glows with color against a damasked ground and with bejeweled finishing touches, setting off the well-shaped volumes of the sacred figures, rapt and remote despite the gentleness of the gestures of blessing.

But to find examples of mural paintings of a monumental dimension (the genre in which Gozzoli was best able to express his compositional and narrative skill) from the Pisan period, other than the Camposanto, it is necessary to move outside the city, following the routes through the territory which were always so congenial and familiar to Benozzo. Here we can find frescoes of shrines as large as small temples and, not without a sense of surprise, recognize in them the grandeur of composition of genuine cycles of sacred themes.

At Legoli near Peccioli (Pisa), where the Gozzoli family took refuge from the plague in 1478-9, Benozzo painted various scenes, which have unfortunately come down to us in a fragmented and patchy state: the *Madonna and Child with Four Saints*, *The Evangelists*, *The Doctors of the Church*, *Christ giving his Blessing*, the *Annunciation*, the *Journey to Calvary*, the *Crucifixion and Saints*, *Saint Michael Archangel*, the *Disbelief of Saint Thomas*, and the *Martyrdom of Saint Sebastian*. Vigorous and almost crude, Benozzo here takes the customary language to a higher degree of pathos, translating into the effective and direct formulas of a rather summary and rustic style such courtly prototypes as Verrocchio's bronze group of the *Disbelief of Saint Thomas* in Orsanmichele, which appears to have influenced the picture of the same subject in Gozzoli's shrine. The works in Volterra, to which Vasari makes a vague reference, may date from around the same time. All that has survived is the fresco decoration of a niche in the oratory of the Virgin in the Cathedral, with a *Journey of the Magi* that served as a backdrop to an *Adoration of the Magi* modeled in polychrome terracotta in the Della Robbia style. The fresco contains some distant echoes of the same subject so sumptuously treated in the Medici chapel, but a more sober and everyday tone prevails; with greater fidelity to an established iconographic tradition, the three Wise Men ride alongside one another, instead of being formally separated and escorted.

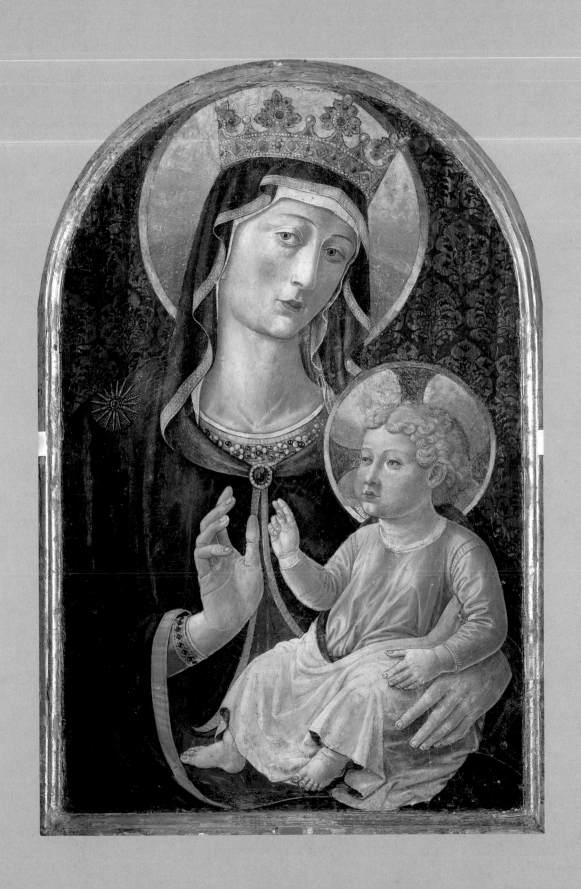

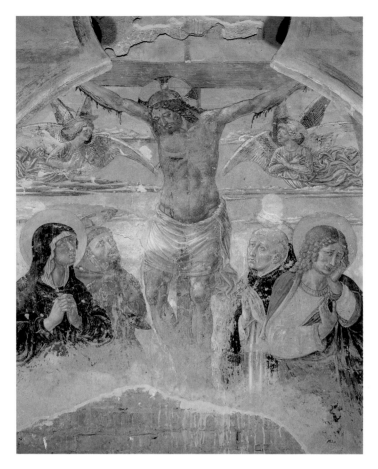

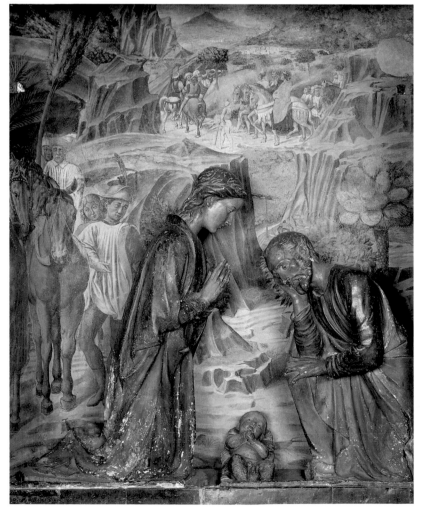

93. Shrine of Legoli
Crucifixion
Peccioli (Pisa)

94. Shrine of Legoli
Disbelief of Saint Thomas
Peccioli (Pisa)

95. *Cavalcade of the Magi*
Volterra, Cathedral

96. *Shrine of the Madonna della Tosse*
Castelfiorentino, Biblioteca Comunale

Two more monumental shrines, of proportions similar to those of true chapels, were frescoed by the Gozzoli family at Castelfiorentino, on the initiative of a single client, Ser Grazia di Francesco, prior of Santa Maria at Castelnuovo Val d'Elsa. The records cast some doubt on the honesty of this prelate, but he was certainly active in the restoration and commissioning of works of art. In 1484, toward the end of the work in the Camposanto, Benozzo frescoed the shrine of the *Madonna della Tosse* at Castelnuovo for Ser Grazia, where there remains a memorial tablet with the inscription "HOC TABERNCVLVM FECIT FIERI D[OMI]N[V]S GRATIA PRIOR CASTRI NOVI AD HONOREM S[AN]C[T]E MARIE VIRGINIS DIE XXIIII DECEMBRIS MCCCCLXXXIIII", together with a number of fragmentary writings on the paintings. The shrine was transformed into a small chapel in 1853 by the construction of a Neo-Gothic facade, but this was not sufficient to arrest the deterioration of the murals. Detached and restored in 1970, they have been remounted in the Biblioteca Comunale. The decoration hinges around a mock altarpiece with predella (it is actually a fresco) depicting the *Madonna nursing the Child* with Saints Peter, Catherine, Margaret, and Paul, framed by a red drape held up, as always in Benozzo's paintings, by small angelic figures. On the one hand this illusionistic device is simpler than the subtle and elaborate *trompe l'oeil* of his youthful work in Montefalco, but on the other it is rendered more effective by the additional optical illusion of a cuspidate picture with the *Face of Christ* painted as if it had been left leaning, in a casual act of devotion, against the lower edge of the altarpiece. With details like this Benozzo showed that he was not stuck in repetitive schemes, but capable of keeping abreast of the latest developments in artistic research, which in the eighties had in fact turned its attention to the artifices of illusionism in painting. On the cross vault are depicted the four *Evangelists* and *Christ giving his Blessing*, on the keystone. The *Dormitio Virginis* is on the left wall and the *Assumption*, with the delivery of the Virgin's girdle to St Thomas, on the right wall. The mature prelate kneeling near the Virgin Mary in the *Dormitio* is usually identified as Ser Grazia, while the identities of the two young men on their knees on the right and the small devotee on the left in the *Assumption* are not known. The fading or even complete disappearance of the more fragile zones of color, such as the foliage of the trees and various items of clothing, has greatly impoverished the scenes, in which Benozzo has

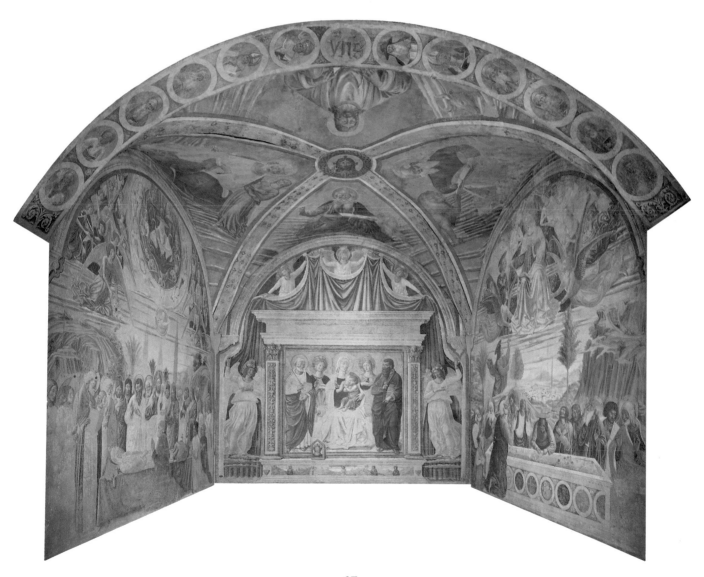

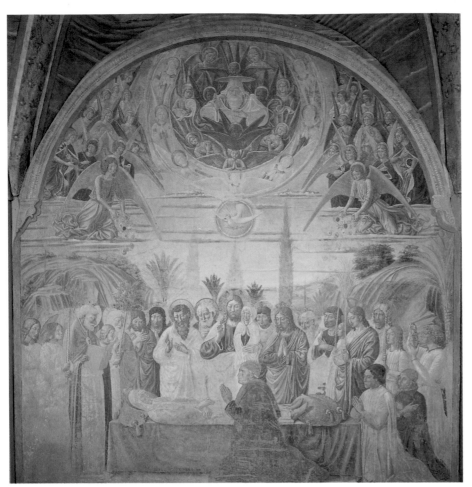

97. *Shrine of the Madonna della Tosse*
Dormitio Virginis
Castelfiorentino, Biblioteca Comunale

98, 99. *Shrine of the Madonna della Tosse*
Assumption of the Virgin
Castelfiorentino, Biblioteca Comunale

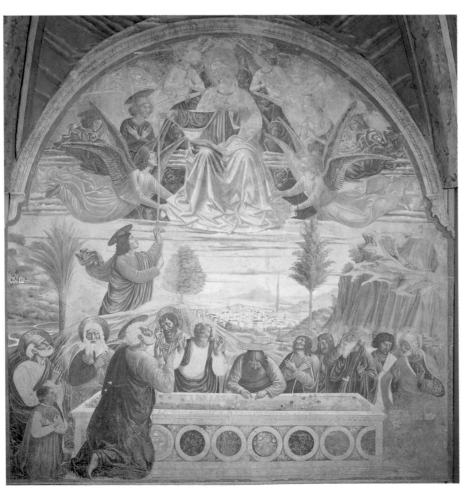

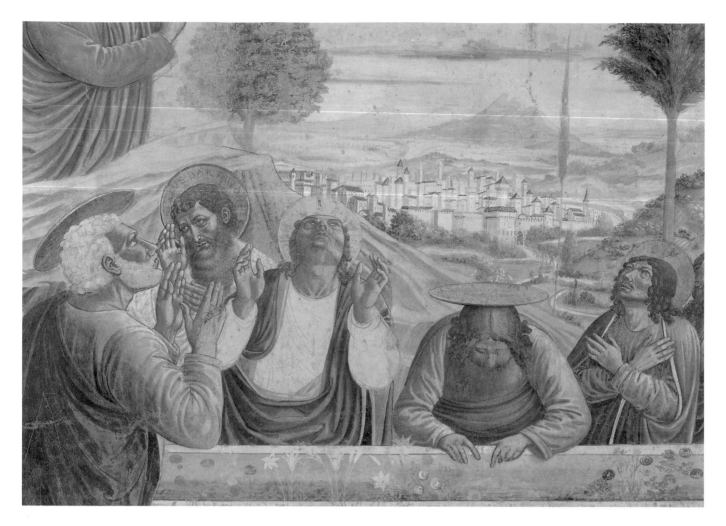

sought variety within symmetry, emphasizing the correspondences between the two wall scenes: note the Eternal in the *Dormitio* and the Virgin Mary in the *Assumption* supported by angels, the catafalque and the sarcophagus, and the group of Apostles in both scenes. The decoration of the sarcophagus with discs of rare marble does not correspond to a now widespread fashion, but evokes the ornamentation of the base of the Chapel of the Magi, in which Benozzo had experimented with a pioneering revival of ancient marble encrustations. Among the assistants who were given the job of translating the master's ideas into painting was probably his son Francesco.

The second shrine painted at the expense of Ser Grazia, known as the "shrine of the Visitation," was located on Via Volterrana in Castelfiorentino, on a piece of land belonging to the Minorite nunnery of Santa Maria. Painted on the outside as well as the inside, it was exposed to the elements until 1872 when the Ministry of Public Education had it enclosed in a small chapel, but without repairing the damage caused by the flooding of the Elsa. As with the previous one, it proved necessary to detach the paintings, which can now be seen in the Biblioteca Comunale of Castelfiorentino. A lost inscription, known to us through an inexact transcription made in the seventeenth century, mentioned Benozzo and his sons Francesco and Alesso as the authors and gave the date as February 12, 1491 (1490 Florentine style). The pictorial ornamen-

tation of the shrine has the consistency of an imposing mural cycle, divided into rows. On the altar wall, perhaps with an effect similar to that of the shrine of the *Madonna della Tosse*, there was an altarpiece depicting the *Madonna and Saints*. All that remains is the upper part of the *sinopia* found during the detachment of the frescoes: it is known from an old description that the saints were Paul, Lawrence, Stephen, Peter, Francis, and Clare (Proto Pisani 1987, p. 36). The arched vault, which has the *Annunciation* on the outside, bears the images of *Christ giving his Blessing* and, underneath, the Evangelists and the four Doctors of the Church, Gregory, Jerome, Ambrose, and Augustine. They are followed, on the outside and inside, by scenes from the life of the Virgin: *Joachim Expelled from the Temple*, the *Annunciation to Joachim*, the *Meeting at the Golden Gate*, and the *Nativity of Mary*. Only the upper part remains of the *Presentation in the Temple*, the *Wedding of the Virgin*, the *Visitation* from which the shrine takes its name, the *Nativity of Jesus*, and the *Adoration of the Magi*. Two drawings (London, British Museum no. 1895-9-15-445, and Munich, Staatliche Graphische Sammlung no. 34520) can be linked with these scenes. Probably by Alesso, they are not so much preparatory drawings as ones made *d'après*. The *sinopie* on the other hand, brought to light during the detachment of the decoration in 1965, are Benozzo's own work and true masterpieces of design. Although much of the execution was en-

trusted to his sons and assistants, the inventions and design of the shrine of the *Visitazione* clearly bear the stamp of Benozzo. Although unable to avoid the occasional clumsiness (see the *Annunciation to Joachim*, with its disproportionately small shepherds, at least one of which was slavishly copied from the Chapel of the Magi), he still maintains control over his typical, unmistakable alternation between Arcadian scenery and urban settings, between courtly atmosphere and everyday events. It looks as if the elderly Benozzo was trying to get his group to compete, at a distance, with the much more experienced one that was assisting Ghirlandaio in his work on the decoration of Santa Maria Novella.

Forced to leave Pisa, along with other Florentine residents of the city, following the invasion by Charles VIII and the expulsion of the Medici, Benozzo returned to Florence. There however, aging and lacking the support of his former Medicean patrons, he would have found it difficult to compete with more established fresco painters. We find him there, in January 1497, in the company of three other famous painters, Filippino Lippi, Cosimo Rosselli, and Perugino, appraising the murals of Baldovinetti in the choir of Santa Trinità. But sometime during the next few months he must have moved to Pistoia, where his sons Francesco, a "painter of boxes", and Giovan Battista, a judge, were already working (Padoa Rizzo 1989, p. 17). He had probably been summoned there by the city government to fresco a large *Maestà* in the City Hall. In fact Benozzo died in Pistoia on October 4, 1497, probably of the plague, and was buried in the cloister of the convent of San Domenico.

The works, not numerous but remarkable, of this last period that came to an end in Pistoia reveal in Benozzo what is, after all, a fairly unpredictable capacity to change the course of his style, under the powerful impetus of a profound and sincere spiritual upheaval. Whether or not he had heard Savonarola in Pisa, when the latter had preached in Santa Caterina in the spring of 1492, Benozzo, who had spent the years of his artistic apprenticeship with the reformed Dominicans of San Marco, was turned by the sense of ardent and tragic piety that Savonarola inspired toward a more severe interpretation of sacred painting, in which the aspect of outer magnificence gave way to impassioned dramatic expression. And we cannot fail to wonder at the fact that a painter of over seventy, and one moreover who was prone to the repetition of pleasing and successful formulas, was able to take a completely new direction, sacrificing, as if on a personal "bonfire of vanities," his most deep-rooted professional habits in order to take the arduous route of a new and penitential austerity.

The day before the master's death, the bishop of Pistoia, Lorenzo Pandolfini, received from the former's sons two paintings in oil on canvas that were a full expression of his new spirituality: the *Descent from the Cross* and the *Raising of Lazarus*. The first picture, of large dimensions (180 x 300 cm), remained in the possession of the Pistoian clergy until the beginning of this century, when it was acquired on the antique market by the collector and art historian Herbert Horne, and is now in the museum of the same name. The subject, which Benozzo had never previously tackled with such solemn monumentality, retains distant hints of Fra Angelico in the composition, but as a whole is treated with that skillful mastery of the distribution of groups in three-dimensional space that the artist had demonstrated in the Camposanto in Pisa. The forceful asymmetry in the background, where the "void" of the landscape is juxtaposed with the "solid" of the stony tomb on the right, accentuates the sense of painful imbalance that predominates at the center of the painting, in the inert body of Christ lowered by four men, far more forlorn and pathetic than the rigid corpse of the same scene in the *Shrine of the Executed* in Certaldo. It is difficult to make any judgments about the quality of the painting, as the technique was such an unusual one for Benozzo and the picture has suffered extensive damage, which the recent restoration (1991) has been able to remedy only in part. However great delicacy of execution can be seen in the modeling of the bodies and drapery, with their clear and gleaming highlights. In my view the large Horne canvas is most closely related not to the works in Pisa (Padoa Rizzo 1992, p. 122), but to the predella of a painting that has not yet been identified in the Dower House Collection, Melbourne (G.B.), depicting the *Lament over the Dead Christ*. In spite of its small size, this is characterized by a greater complexity and dynamism of composition than any of Gozzoli's other predellas and contains a group of figures very similar, though drawn out to fit the horizontal format, to the one in the Horne *Deposition*, at top right.

The second canvas acquired by the bishop of Pistoia, the *Raising of Lazarus* in the National Gallery in Washington, is smaller but no less solemn. While the open landscape, with large towns and villages, diverges from Gozzoli's conventions and takes on an unprecedented vitality, especially in the high mountain in the background, the figures depicted with a few essential strokes, clumped in astonished groups, observe one of Christ's most disturbing miracles in dumbfounded silence. Although the dull and burned tones of the painting can probably be imputed to the alteration of pigments and binders and to the overall deterioration of the surface, and should not be considered a conscious decision on the painter's part, it is undeniable that this "poor" palette adds an air of mortification and severity to this rare Gospel theme, of distinctly Savonarolan stamp. Another of Gozzoli's last works that is known to us is a small *Saint Jerome in the Desert* on board in the Corsi Collection (Florence, Museo Bardini). It too is penitential in its atmosphere, only edgily enlivened by threadlike highlights.

At the time of his death Benozzo was working on two paintings in Pistoia, very different in their dimen-

100. Shrine of the Visitation
Castelfiorentino, Biblioteca Comunale

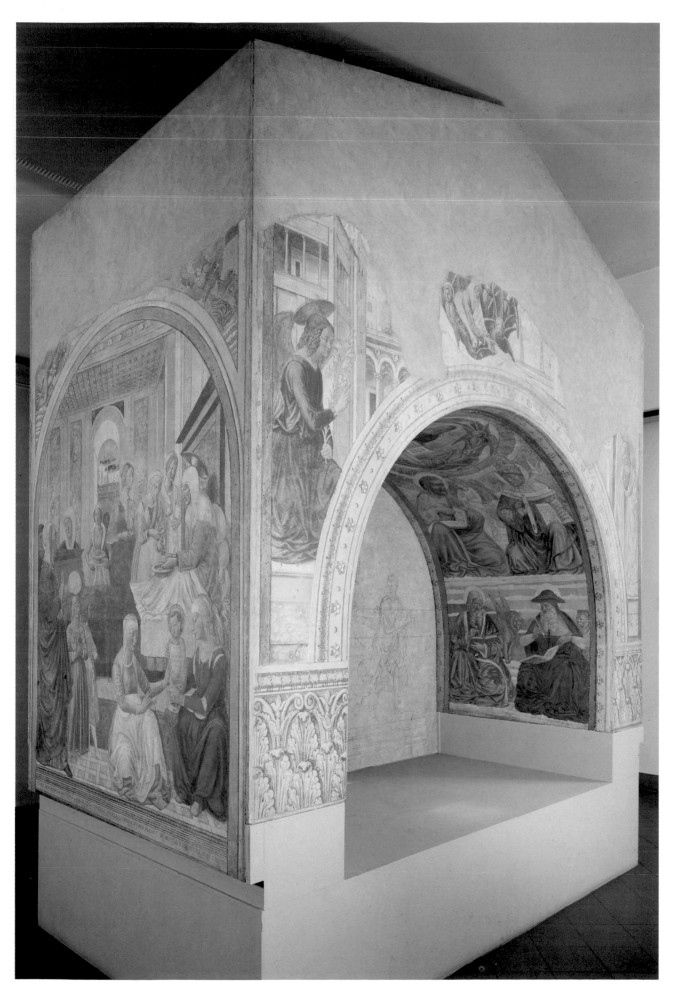

71

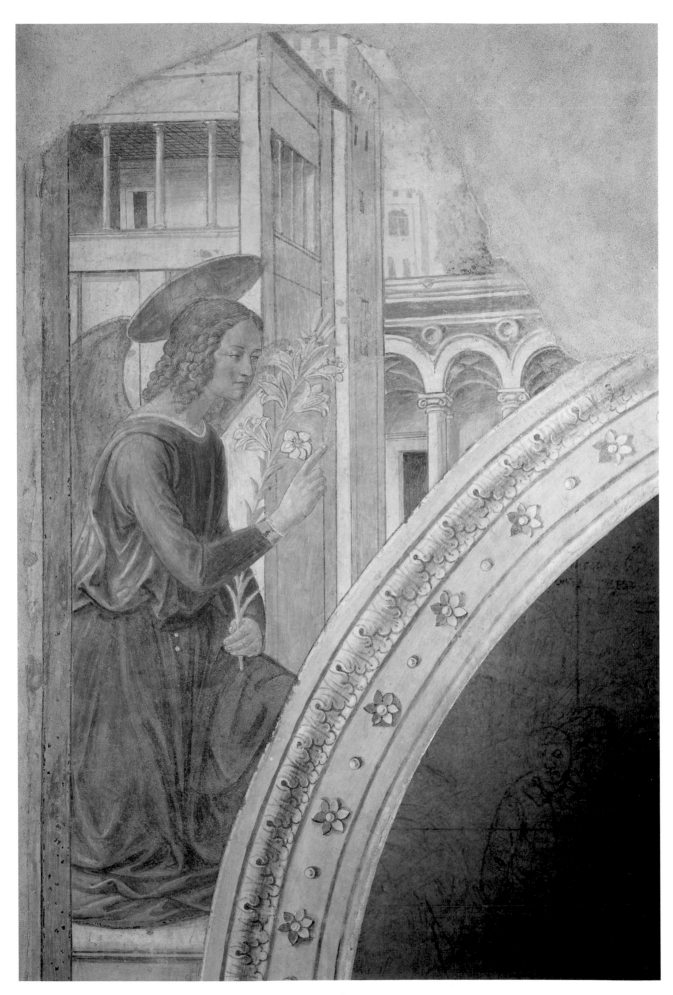

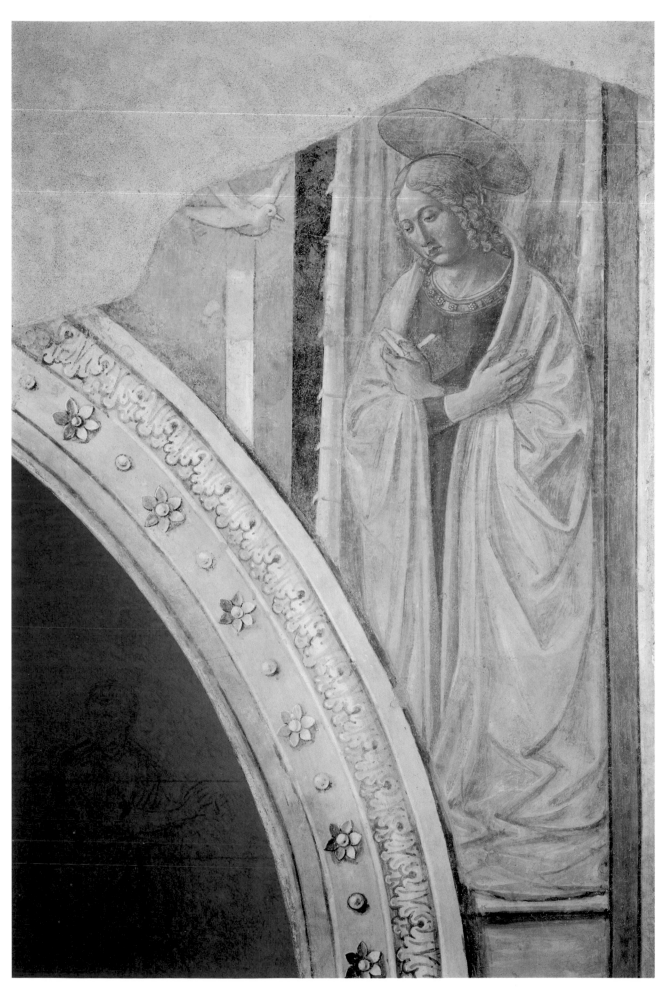

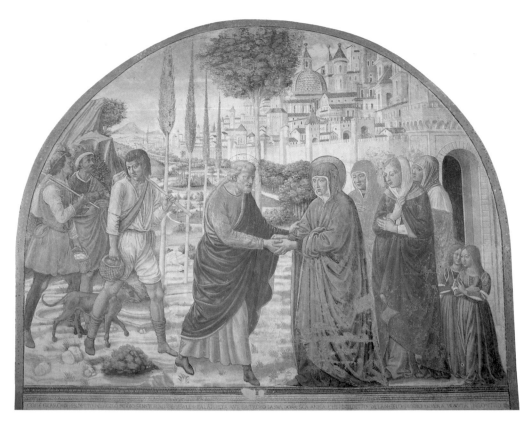

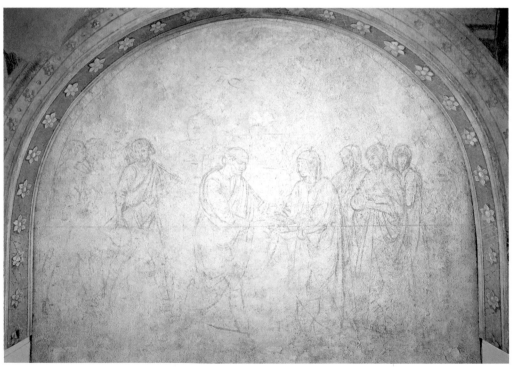

sions and the degree of effort involved, in yet another demonstration if more were required of how this truly complete painter, with a "fully rounded" professional figure, was considered capable of taking on any commission and carrying it out to the client's satisfaction. They are a large fresco and a miniature, both attributed to Gozzoli by Padoa Rizzo (1986 and 1989). The fresco, which has already been mentioned, remained in the state of a *sinopia* or drawing on the wall. It was to have represented, on a wall of the "Sala Ghibellina" in the Pistoia City Hall, the *Madonna Enthroned in Majesty*, surrounded by angels and saints: the latter were either patrons of the city or intercessors against plagues: Agatha and Eulalia, James, perhaps Rock, Zeno, and Atto (or Martin). The idea of summoning Benozzo to paint the *Maestà* may have come from the Florentine Giuliano di Francesco Salviati, captain in Pisa at the time and a relative of the Lotto for whom Benozzo had already worked in Pisa. For the composition, Benozzo combined the usual scheme of the *Sacra conversazione* against the backdrop of a drape supported by angels with the extended and solemn

105. *Shrine of the Visitation*
Annunciation to Joachim
Castelfiorentino, Biblioteca Comunale

106. *Shrine of the Visitation*
Joachim Expelled from the Temple
Castelfiorentino, Biblioteca Comunale

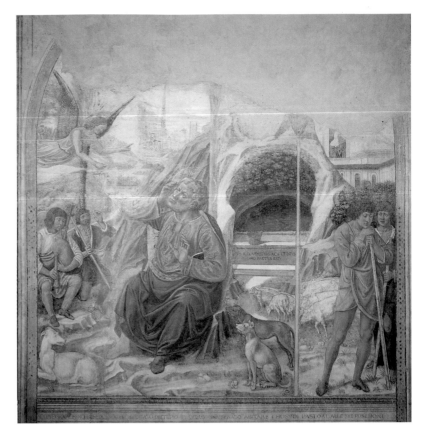

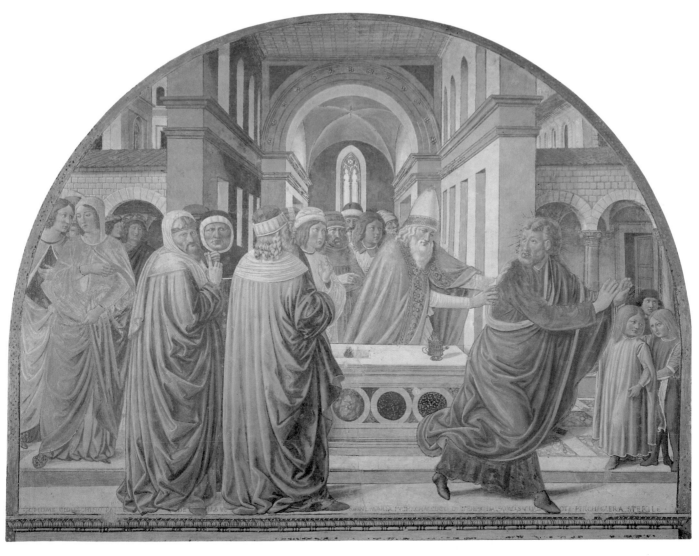

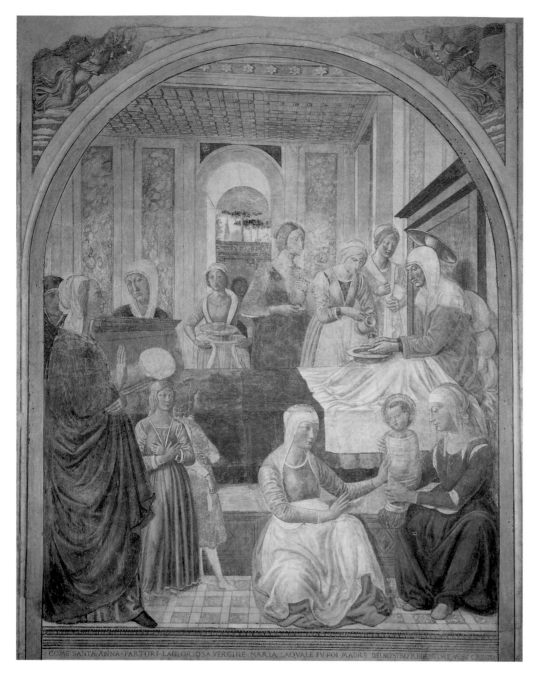

COME·SANTA·ANNA·PARTORI·LAGLORIOSA·VERGINE·MARIA·LAQVALE·FV·POI·MADRE·DELNOSTRO·REDENTORE·YESV·CRISTO

*107. Shrine of the
Visitation
Nativity of Mary
Castelfiorentino,
Biblioteca Comunale*

*108. Descent from the
Cross
180x300 cm
Florence, Museo Horne*

*109. Raising of Lazarus
65.5x80.5
Washington, National
Gallery of Art*

layout of the Gothic *Maestà*, a fine example of which he had encountered during his restoration of Lippo Memmi's painting in San Gimignano. The completeness of the *sinopia* as far as details, attributes, and the marking of light and shade are concerned suggests that Benozzo had no intention of subjecting himself to the fatigue of applying the paint in fresco, but would have left it to his sons and young assistants, having provided them with a detailed design. On the other hand he may himself have painted the decorative scene at the beginning of an anthem book in the Franciscan convent of Giaccherino (MS VI, FF, on c.67) representing the *Dream of Innocent III*, for which a shaded drawing survives. On a very small scale the scene reproduces the layout of the corresponding fresco in Montefalco, but accentuates its sense of drama: in fact the church does not so much loom over St Francis as threaten him, falling on top of him as the

tympanum at the summit and the bell tower collapse.

Even in these last unfinished and moving pictures, Benozzo's art retains its distinctive features: his familiarity with and admiration for the great Tuscan tradition of Gothic painting, whose legacy he inherited and used to advantage; his incorporation of the classical ideas of Humanism, in the measured and delicate manner imbibed from Ghiberti; his seriousness and almost uninterrupted dedication to sacred art, channeled by a Christian *pietas* assimilated from Fra Angelico and practiced with personal conviction. From this perspective, the highest and most successful examples of Benozzo's painting where the richness of composition goes hand in hand with a meticulous use of the brush, paying minute attention to the most exquisite detail, can be considered an unbroken celebration of God's work, as reflected in the beauty of nature and of human works.

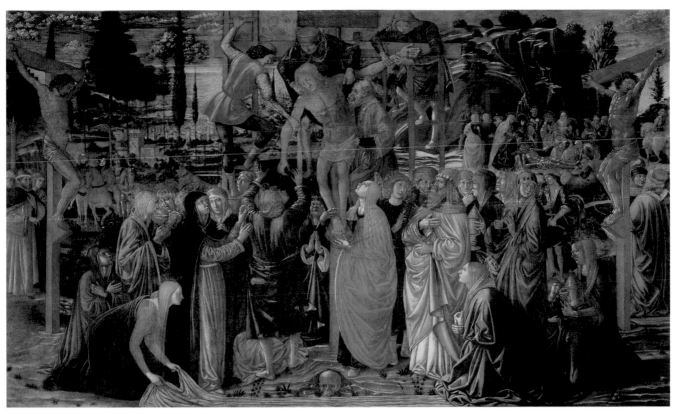

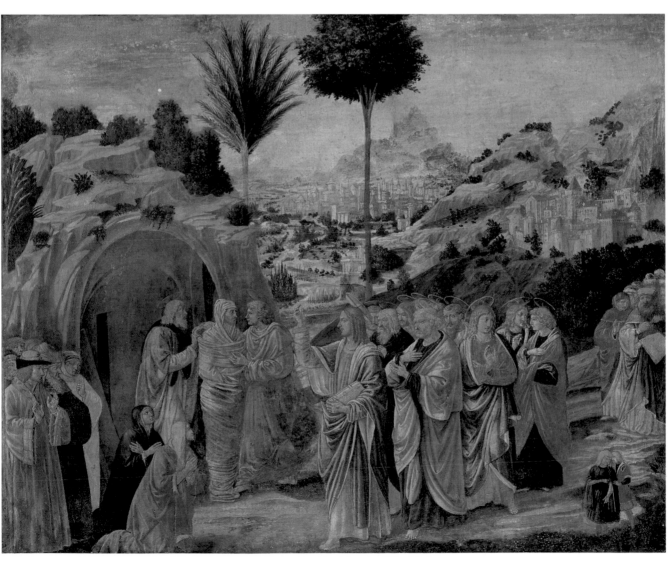

Essential Bibliography

[Antonio Billi] *Il libro di Antonio Billi* (c. 1516-30), Ed. C. von Fabriczy, Florence 1981.

Anonimo Magliabechiano, *Il Codice dell'Anonimo Magliabechiano* (c. 1542-48), edited by K. Frey, Berlin 1892.

G. VASARI, *Le Vite de' più eccellenti pittori, scultori, e architettori* (1568), Ed. G. Milanesi, Florence 1878 vol. II.

G. GAYE, *Carteggio inedito di artisti dei secoli, XIV, XV, XVI*, Florence I, 1839; II, 1840.

E. MÜNTZ, *Les Arts à la cour des Papes*, Rome 1878.

L. FUMI, *Il Duomo di Orvieto*, Rome 1891.

G. MILANESI, *Nuovi documenti per la storia dell'arte toscana*, Rome 1893.

B. BERENSON, *The Florentine Paintings of the Renaissance*, New York 1900.

E. LASINIO, *Il Camposanto e l'Accademia di Belle Arti di Pisa, dal 1806 al 1838 nelle memorie e nelle carte di C. Lasinio*, Pisa 1992.

D.E. COLNAGHI, *Dictionary of Florentine Painters*, London 1928.

I Mostra di affreschi staccati, catalogue, Florence 1957.

II Mostra di affreschi staccati, catalogue, Florence 1958.

M. SALMI, *Il Beato Angelico*, Spoleto 1958.

M. BUCCI-L. BERTOLINI, *Camposanto monumentale di Pisa*, Pisa 1960.

R. LONGHI, *Una Crocefissione di Benozzo giovine*, in "Paragone", no. 123, 1960, pp. 3-7.

U. PROCACCI, *Sinopie e affreschi*, Milan 1960.

M. DAVIES, *National Gallery Catalogues, Earlier Italian Schools*, London 1961.

Arte in Valdelsa, catalogue, Certaldo 1963.

A. GROTE, "Gozzoli's Frescoes in the Palazzo Medici Riccardi. A Hitherto Unpublished Letter," in *Journal of the Warburg and Courtauld Institutes*, XXVII, 1964, pp. 321-322.

S. NESSI, "Un restauro di Benozzo Gozzoli a Montefalco," in *Commentari*, XVI, 1965, pp. 222-224.

M.G. CIARDI DUPRÉ DAL POGGETTO, "Sulla collaborazione di Benozzo alla Porta del Paradiso," in *Antichità Viva*, VI, no. 6, 1967, pp. 60-73.

R. HATFIELD, "The Compagnia dei Magi," in *Journal of the Warburg and Courtauld Institutes*, XXXIII, 1970, pp. 107-161.

F. ZERI-E. GARDNER, *Italian Paintings. A catalogue of the collection of the Metropolitan Museum of Art. Florentine School*, New York 1971.

A. PADOA RIZZO, *Benozzo Gozzoli pittore fiorentino*, Florence 1972.

Mostra del Restauro, catalogue, Pisa 1972.

U. BALDINI, "Gozzoli inedito," in *La Nazione*, December 23, 1972.

B. FREDERICKSEN-F. ZERI, *Census of Pre-Nineteenth Century Italian Paintings in North American Public Collections*, Cambridge Mass. 1972.

E. CARLI, *Il Museo di Pisa*, Pisa 1972.

L. FRERCHS, "Een verloren gegaan werk van Benozzo Gozzoli; het fresco met de Dood van Mozes," in *Bulletin van het Rijksmuseum*, 22, 1974, pp. 65-80.

"Benozzo Gozzoli a Legoli," in *Volterra*, 15, 1976, part 2, p. 26.

M.G. CIARDI DUPRÉ DAL POGGETTO, G. MOROLLI, "La porta del Paradiso. I collaboratori, Benozzo Gozzoli," in *Lorenzo Ghiberti. Materia e ragionamenti*, exhibition catalogue, Florence 1978, pp. 397-398.

E. CARLI, *Volterra nel Medio Evo e nel Rinascimento*, Pisa 1978.

A. CHASTEL, "Le arti nel Rinascimento," in *Il Rinascimento. Interpretazioni e problemi*, Bari 1979, pp. 275-332.

A. CALECA-G. NENCINI-G. PIANCASTELLI, *Il Museo delle sinopie del Camposanto monumentale*, Pisa 1979.

J. POPE HENNESSY, "The Ford Italian Paintings," in *Bulletin of the Detroit Institute of Art*, LVII, 1979, no. I, pp. 15-23.

A. GRECO, *La cappella di Niccolò V del Beato Angelico*, Rome 1980.

H. HIBBARD, *The Metropolitan Museum of Art*, New York 1980.

C. MELI, "San Gimignano," in *Storia dell'Arte Italiana*, p. III, vol. I: *Inchieste su centri minori*, Turin 1980, pp. 107-132.

A. PADOA RIZZO, "Note su un San Gerolamo penitente di Benozzo," in *Antichità Viva*, XIX, no. 3, 1980, pp. 14-19.

Il tesoro della basilica di San Francesco ad Assisi, catalogue, Assisi-Florence 1980.

European Paintings in the Metropolitan Museum of Art. Summary catalogue, New York 1980.

Catalogue sommaire illustré des peintures du Musée du Louvre. Italie, Espagne, Allemagne, Grande Bretagne et divers, Paris 1981.

H. KIEL, "Das Sinopienmuseum in Camposanto am Dom zu Pisa," in *Pantheon*, XXXIX, 1981, pp. 127-8.

P. HURTUBISE, "Lotto di Giovanni Salviati and the 'Virgin and Child with Saints' by Benozzo Gozzoli in the National Gallery of Canada," in *National Gallery of Canada Annual Bulletin*, 5, 1981-1982, pp. 29-35.

K. CHRISTIANSEN, "Early Renaissance Narrative Painting in Italy," in *Bulletin of Metropolitan Museum of Art*, LI, 1983, no. 2, pp. 1-48.

J. SHEARMAN, *The Early Italian Pictures in the Collection of Her Majesty the Queen*, Cambridge 1983.

Early Italian Paintings and Work of Art. 1300-1480, Matthiesen Fine Art, London 1984.

A. PADOA RIZZO-M. CASINI WANROOIJ, "Appunti sulla pittura fiorentina del Quattrocento: Benozzo Gozzoli, Domenico di Michelino," in *Antichità Viva*, XXIV, 1985, nos. 5-6, pp. 5-17.

S. PASTI, "Una Madonna quattrocentesca a S. Maria sopra Minerva: un'ipotesi per l'Angelico, Benozzo e il Vasari," in *Bollettino d'Arte*, LXX, series VI, no. 29, 1985, pp. 57-67.

D. COLE AHL, "Benozzo Gozzoli's Frescoes of the Life of Saint Augustine in San Gimignano: their Meaning in Context," in *Artibus et Historiae*, XIII, 1986, pp. 35-53.

Il Museo dell'Opera del Duomo a Pisa, edited by G. de Angelis D'Ossat, Milan 1986.

E. GIESE, *Benozzo Gozzoli's Franziskuszyklus in Montefalco*, Frankfurt 1986.

J.P. MARANDEL, "A Valentiner legacy: the broad stream of european painting," in *Apollo*, CXXIV, 1986, no. 298, pp. 486-497.

M. TAZARTES, "Pittura del Quattrocento a Pisa e a Lucca," in *La pittura in Italia. Il Quattrocento*, Milan 1986.

Disegni Italiani del tempo di Donatello, exhibition catalogue, Florence 1986.

G. CACIAGLI, *Benozzo Gozzoli e il Tabernacolo di Legoli*, Pisa 1987.

R. CATERINA PROTO PISANI-A. PADOA RIZZO, *Gli affreschi di Benozzo Gozzoli a Castelfiorentino (1484-1490)*, Pisa 1987.

A.M. ROBERTS, "North meets South in the Convent: the Altarpiece of Saint Catherine of Alexandria in Pisa," in *Zeitschrift für Kunstgeschichte* L, 1987, pp. 441-470.

M. LASKIN-M. PANTAZZI, *European and American Painting, Sculpture and Decorative Arts*, Ottawa 1987.

D. COLE AHL, "Due San Sebastiano di Benozzo Gozzoli a San Gimignano: un contributo al problema della pittura per la peste nel Quattrocento," in *Rivista d'Arte*, XL, 1988, series IV, vol. IV, pp. 31-62.

A. RONEN, "Gozzoli's St. Sebastian altarpiece in San Gimignano," in *Mitteilungen des Kunsthistorischen Institutes in Florenz*, XXII, 1988, pp. 77-126.

C. GILBERT, *L'arte del Quattrocento nelle testimonianze coeve*, Florence-Vienna 1988.

Il Duomo di Orvieto, Rome-Bari 1988.

A. PADOA RIZZO, *Arte e committenza a Pistoia alla fine del XV secolo: Benozzo Gozzoli e i figli Francesco e Alesso. Nuove ricerche*, Pistoia 1989.

F. TODINI, *La pittura umbra dal Duecento al primo Cinquecento*, Milan 1989.

La chiesa e il convento di San Marco a Firenze, Florence 1990.

Pittura di luce, exhibition catalogue edited by L. Bellosi, Milan 1990.

L'Età di Masaccio, exhibition catalogue edited by L. Berti e A. Paolucci, Milan 1990.

A. PADOA RIZZO, review of *L'Età di Masaccio*, in *Antichità Viva*, XXIX, 1990, 5, pp. 56-59.

P. TORRITI, *La Pinacoteca Nazionale di Siena. I dipinti*, Genoa 1990.

Museo Comunale di San Francesco a Montefalco, Perugia 1990.

La Cattedrale di Orvieto Santa Maria Assunta in cielo, edited by G. Testa, Rome 1990.

C. ACIDINI LUCHINAT, "La cappella attraverso cinque secoli," in G. Cherubini and G. Fanelli (ed. by), *Il Palazzo Medici Riccardi di Firenze*, Florence 1991.

C. GIANNINI, "Vicende allestimenti patrimonio artistico in Palazzo Medici Riccardi," in *Antichità Viva*, XXX, 1991, nos. 1-2, pp. 43-52.

"Per bellezza, per studio, per piacere". Lorenzo il Magnifico e gli spazi dell'arte, edited by F. Borsi, Florence 1991.

A. PADOA RIZZO, "L'attività di Benozzo Gozzoli per la Compagnia di Sant'Agnese (1439, 1441)," in *Rivista d'Arte*, XLIII, 1991, s. IV, vol. VII, pp. 203-211.

C. ACIDINI LUCHINAT (editor), *I restauri nel Palazzo Medici Riccardi, Rinascimento e Barocco*, Milan 1992.

A. PADOA RIZZO, *Benozzo Gozzoli. Catalogo completo*, Florence 1992.

M. GREGORI, A. PAOLUCCI, C. ACIDINI LUCHINAT (editors), *Maestri e botteghe. Pitture a Firenze alla fine del Quattrocento*, catalogue, Milan 1992.

M.G. BURRESI (editor), *Nel secolo di Lorenzo — restauri di opere d'arte del Quattrocento*, Pisa 1993.

C. ACIDINI LUCHINAT (editor), *Benozzo Gozzoli. La Cappella dei Magi*, Milan 1993.

Index of Illustrations